LEGENDS & LORE

OF

CAPE COD

LEGENDS & LORE
OF
CAPE COD

ROBIN SMITH-JOHNSON

THE
History
PRESS

Published by The History Press
Charleston, SC
www.historypress.net

Front cover, top left: Bird carver A. Elmer Crowell in his workshop. *From the postcard collection of Wendell E. Smith*; *bottom*: A vintage postcard of bathers at Brown's Bathing Beach in Provincetown. *From the postcard collection of Wendell E. Smith.*

First published 2016

Manufactured in the United States

ISBN 978.1.46711.904.7

Library of Congress Control Number: 2015960005

This book is dedicated to the Smith Family Writers.
You share my love of the written word and have supported me in so many ways.

CONTENTS

Acknowledgements 9
Introduction 11

Ancient Cape Cod 13
Legendary Miscreants 17
The Arctic Explorer from Provincetown 21
Fantastic Creatures 25
Murder Most Foul 31
Gentle Legends 37
The Disappearance of Billingsgate Island 43
Village Vignettes 47
Unsolved Mysteries 55
Medical Maladies 59
Haunted Places 63
Wampanoag Tales 69
Cape Cod Oddities 75
Ill-Fated Sea Voyages 79
A Cape Cod Love Story 87
Local Legends 89
Believe it or Not 97
Goblins and Ghosts 103
Inspirational Legends 107
The Auctioneer and the Air Crash 113
Hurricanes and Other Disasters 115

CONTENTS

UFO Sightings: Fact or Fiction 123
Cape Cod Eccentrics 127
Legendary Hyannis Port 131

Author's Note 135
Bibliography 137
About the Author 141

ACKNOWLEDGEMENTS

This book has been a labor of love, and I could not have done it without the help of libraries and individuals on Cape Cod.

First, I would like to thank Mary LaBombard, Special Collections librarian and archivist in the W.B. Nickerson Room at Cape Cod Community College. She was kind enough to help me pick out photographs for this volume. I would also like to thank the staff at the Mashpee Public Library and Hyannis Public Library for guiding me to period books that helped me in my research. Thanks also to Bonnie Snow of the Orleans Historical Society for help with background on early Orleans history.

I wish to thank Paul Pronovost, editor of the *Cape Cod Times*, for permission to use *Cape Cod Times* photos. Steve Heaslip, *Cape Cod Times* photographer, and Ritchie Kolnos, IT specialist at the *Cape Cod Times*, were instrumental in helping me with my photos as well. I would also like to thank *Cape Cod Times* photographer Merrily Cassidy for the author photo.

I would like to thank my mother, Muriel Smith, for sharing the postcard collection from the estate of my late father, Wendell Everett Smith, an antiquarian book dealer. I'm grateful to my readers Gregory R. Johnson and Cynthia Sherrick Mitchell. I especially wish to thank my reader and editor, Devin Wells Johnson.

I'm indebted to my professional colleagues who encouraged me in this endeavor, including James Kershner, English professor at Cape Cod Community College; Barbara Clark of the *Barnstable Patriot*; and Gwenn Friss and Susan Eastman of the *Cape Cod Times*.

Acknowledgements

Finally, I would like to thank the hardworking people at The History Press—Tabitha Dulla, acquisitions editor, for bringing me on board with this project, and Karmen Cook, acquisitions editor, for following through with the book.

I would like to thank my family for their uncomplaining support. It has been a wonderful journey of historical research and exploration.

INTRODUCTION

As a longtime resident of Cape Cod, I have an avid interest in the old tales and historical treasures of Cape Cod. This interest has been sharpened and honed by my many years working as the newsroom librarian at the *Cape Cod Times*. I have access to archives and old clip files that contain stories about Cape Cod that people may have never heard about. It's as if I have the whole history of Cape Cod at my fingertips.

Several years ago, I began a Cape History blog entitled "Cape Rewind." It has been an exciting endeavor for me to find unique stories and firsthand accounts to share with my readers. This book is an extension of my research. As I wrote in my very first blog posting: I will try to find stories that appeal to everyone's imagination. Some of these stories may be plain and some fancy; some may cover murder and mayhem or gingham and high tea.

I have chosen to concentrate on the legends and lore of Cape Cod because the stories here have often been handed down from one generation to the next. From the spooky tale of Granny Squannit to the wistful figure of Jenny Lind singing from her tower, the stories are evocative and, hopefully, will encourage readers to do more extensive research on their own.

My searching out of stories has been intuitive and sometimes accidental. Readers will often lead me in directions I had not thought to go. One story may suggest another and I'm off to search the archives again. There are also family ties that have played into my stories. For example, my mother had a tidbit to share that added to the authenticity of Helen Keller's visit here in 1888. My husband's uncle grew up in

Provincetown and remembers the Black Flash of the 1930s. Their stories added richness to my accounts.

Cape Cod is a special place and its history unique in so many ways. In these pages, I hope to present famous and perhaps infamous figures who helped create this "rank, wild place," as David Gessner called the Cape in his memoir of spending a year here. For many, the Cape is a summer retreat and for others, myself included, the Cape is a year-round home. It is indeed a place rich in culture and diversity and I will try to offer stories that show its special nature.

ANCIENT CAPE COD

Cape Cod. The name conjures up images of sandy beaches, kettle ponds and saltwater bays. A hook sticking out into the Atlantic Ocean, Cape Cod was once a peninsula, but with the creation of the Cape Cod Canal in 1914, it is now a man-made island. This landmass formed around twenty-three thousand years ago when glaciers retreated. Once the ice began to melt, the sea began to rise. The deposit of sediment formed what we know as Cape Cod today.

There are varying accounts of how Cape Cod was named. In 1605, explorer Samuel de Champlain called Cape Cod Cape Blanc, for the color of the sand and dunes. In the seventeenth century, explorer Bartholomew Gosnold (1572–1607) explored and named Cape Cod and Martha's Vineyard. Since the waters around the Cape were swarming with cod, he chose that as its handle. Martha's Vineyard was named for Gosnold's infant daughter, Martha.

The common view is that no Europeans set foot in North America before 1492; however, it has been rumored that Leif Ericson of Icelandic fame was one of the first summer visitors to winter on Cape Cod in 1004–05. Some people conjecture that the "Vinland" of Norse sagas referred to Cape Cod, although it is more commonly thought to have been located in the coastal area of Newfoundland. The only known Norse settlement in North America was discovered in 1960 at L'Anse aux Meadows on the northern tip of the island of Newfoundland.

Science fiction writer Frederick J. Pohl visited Cape Cod in the early 1950s and worked to support the theory that Vikings visited Cape Cod by showing

as evidence several holes found in large boulders in Follins Pond near West Dennis that were typical of the type Vikings drilled when mooring their vessels. In the July 1953 issue of the *Bulletin of the Massachusetts Archaeological Society*, Pohl attempted to verify the existence of these holes:

> *The holes which I called to the attention of the officers of the M.A.S. were (except possibly the one in Mill Pond) hand chiseled, presumably with a straight-edged chisel. They were definitely not machine drilled. We know this because they are triangular with the corners rounded. They are not vertical...Imagine the Norsemen in the wilderness centuries ago. Mooring to a tree would require tying and untying a hawser every time the mooring was used. Remember that the Vikings came from a rocky tree-less coastline (Greenland), where it was their custom to moor their ships to rocks.*

A Connecticut author, Charles Boland, was doing research for a book on the Icelandic sagas. He brought his fifteen-year-old son, Barry, to the Cape in 1957 to search Follins Pond, where they hoped to find something pointing to Viking presence. Like Pohl, they were looking in particular for oddly shaped holes chiseled into rocks. He published his findings in the book *They All Discovered America* in 1963.

Later, in 1969, Helge Ingstad, an archeologist, worked to debunk the idea that Vikings came this far south. He contended that the Norsemen under Leif Ericson established a base camp in Newfoundland. He said that the Newfoundland settlement was the only known Viking construction site on the continent. Other historians believed the Vikings might have ventured as far south as Virginia.

In Provincetown, what is thought to be a Viking wall was found in 1853 during a cellar excavation in the West End of the village. The wall, two feet wide by three feet high, matched tales by archeologists that Leif Ericson's brother, Thorvald, had stopped in this area to repair a broken keel. One account is that returning from his stopover in Provincetown, he was shot by Indians with an arrow and buried in Bass Hole.

A 1957 clipping from the *Cape Cod Standard Times* suggests that Yarmouth might have been the location of similar Viking killings. In fact, the article states that Leif Ericson's sister, Freydis, "slew the entire crew of another Viking ship and their camp followers in 1014." The article goes on to say that Freydis murdered unsatisfactory members of her crew.

Other areas of Cape Cod may also contain remnants of Viking visits. A rune stone found in the 1920s on Noman's Land, an island near Martha's

Vineyard, was said to be inscribed with Norse characters. It was discovered by Joshua Crane, on land he bought as a private hunting camp. The island was likely named for a Wampanoag sachem or Indian chief, Tequenoman.

The Wampanoag Indians, native to southeastern Massachusetts and here long before the coming of Europeans, believed that the world was created by Kiehtan, or the one "Great Spirit." They also believed that every person and animal has its own unique spirit. In her book *The Wampanoag and Their History*, author Natalie M. Rosinsky writes, "When hunting an animal, Wampanoag would thank its spirit. They thanked the spirits of the crops for a good harvest. They also thanked the Great Spirit Kiehtan."

In addition, the Wampanoag believed that the giant Maushop created the islands of Martha's Vineyard and Nantucket. One version of the story is that Maushop created Nantucket from snuff out of his pipe. William Scranton Simmons, in his book *Spirit of the New England Tribes*, quoted early historian Francis Baylies: "An offering was made to him [Maushop] of all the tobacco on Martha's Vineyard, which having smoked, he knocked the snuff out of his pipe, which formed Nantucket." This is an early example of the traditional peace offering that still plays an important role in Indian practices. That generosity extended to the help the tribe gave the Pilgrims.

In September 1620, the Pilgrims left England for a new land, and 102 men, women and children set off on a sixty-six-day Atlantic voyage just ahead of bleak winter weather. Of these number, around fifty-two were Separatists. They wanted to escape to a new land and build a community based on their beliefs; some of them died trying. They arrived in November, stopping at

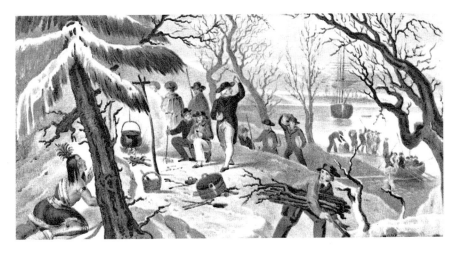

The Pilgrims landing in the New World. *From the postcard collection of Wendell E. Smith.*

Provincetown first, before ultimately settling in Plymouth. Of the 102 who made the long voyage, 42 died that first winter. By Thanksgiving there were only 53 people left to celebrate. Native Americans, including Squanto of the Patuxet tribe (an extinct Native American band of the Wampanoag tribal confederation), greeted the new visitors and taught them how to grow corn, as well as where to fish and hunt beaver. That first Thanksgiving celebration must have been a time for celebration as men, women and children alike feasted with their Wampanoag visitors.

In his book *The Outermost House*, Henry Beston wrote, "In my world of beach and dunes these elemental presences lived and had their being, and under their arch there moved an incomparable pageant of nature and the year." Cape Cod is a magical place, and despite the fact that we may never know everything about its early beginnings, it is a place set apart, a special place.

LEGENDARY MISCREANTS

Passion and Piracy

Pirates have always fascinated the public with their daring adventures and swashbuckling exploits. By definition, piracy means the practice of attacking and robbing ships at sea. Pirates were feared and admired for the lengths they would go to plunder seagoing ships, but even they had to contend with rough seas and a stretch of the Atlantic Ocean often referred to as "the graveyard of the Atlantic." Due to its treacherous shoals, it was the location of numerous shipwrecks.

Cape Codders in the 1600s were familiar with pirates off their coast. In fact, locals often traded with pirates as a way to get around paying taxes and British tariffs. Chatham's founder, William Nickerson, helped a famed English pirate, Dr. John Graham, escape from Nantucket and was later bound over to a Plymouth court in 1684. Provincetown was a favorite smuggling point because the British could not afford to patrol its borders.

The most famous of all Cape Cod pirates was Captain Samuel "Black Sam" Bellamy. This dashing figure wore his long dark hair tied back with a band, unlike most men of that day, who wore powdered wigs. He and his crew were said to have captured fifty ships in little more than a year. His biggest catch was the three-hundred-ton galley slave ship *Whydah* in the spring of 1717. It was reportedly carrying more than $300 million in gold, silver and ivory.

A whimsical illustration of pirate Captain Samuel "Black Sam" Bellamy. *Courtesy of the W.B. Nickerson Archives, Cape Cod Community College.*

It is rumored that he turned to the life of a pirate to support a fifteen-year-old Eastham girl named Maria "Goody" Hallett. When young Bellamy sailed off on his adventures, Maria gave birth to a child who died the same night. She was accused of murdering her infant but was able to escape her jailors. On April 26, 1717, the *Whydah* went down in a great storm off the coast of Cape Cod, and Bellamy drowned with most of his crew. The few surviving pirates were tried, convicted and sentenced to hang in Boston.

According to legend, Maria went mad with grief and spent the rest of her life mourning for her lost love. Some people still believe that her spirit haunts the dunes of the Outer Cape as she waits for the return of her pirate lover. It is easy to imagine her keening into the winds of a nor'easter, her tattered

shawl wrapped closely around her for warmth. Her dream of reuniting with a young love is the stuff of Cape lore.

In 1984, treasure hunter and diver Barry Clifford found the remains of the *Whydah* in waters off Wellfleet. He also found what are believed to be the remains of Captain William Kidd's ship, the *Adventure*, off the coast of Madagascar in 2000.

MOON MAGIC: RUMRUNNERS AND SMUGGLERS

Mooncussers were land pirates who lured ships to shore and then plundered them. On dark, stormy nights, these scoundrels would plant large decoy lanterns and wait for a passing ship. The origin of the term "mooncusser" came about because experienced seamen would not be fooled by such tricks because they knew how to see on moonlit nights. When their ploys didn't work, the villains would shout, "Cuss the moon!"

Others who worked by the light of the moon were the rumrunners of the 1920s and '30s. Large ships would anchor in Massachusetts Bay and then smaller craft would carry the illegal spirits to shore. So prevalent was rumrunning during Prohibition that the Coast Guard made it its main mission in the 1920s to suppress the sale of smuggled alcohol. Manuel "Sea Fox" Zora was the best-known rumrunner in Provincetown during Prohibition.

According to reports from the *Nantucket Inquirer*, rumrunners smuggled alcohol from Canada and made stops in Nantucket. An editorial from the 1920s read, "Those who have an eye on the waterfront have their own opinions as to how liquor finds its way to the island. But it apparently reaches Nantucket with little trouble and is obtainable at a price."

Prohibition ended on December 5, 1933, but smugglers still plied their trade. In later years, drug smuggling became rampant. In the 1960s, a boat carrying marijuana was discovered in Wellfleet Harbor. One infamous drug smuggler was George Jung, who was living on Cape Cod when he was arrested in 1980 and 1983 on drug charges and in 1995, when he was arrested—for the last time—by state and Dennis police at an East Dennis home. Jung had boarded and plastered $500,000 worth of marijuana behind a false board in the basement of the house where he was staying. He was released from federal prison in June 2014. His story was made famous by the 2001 film *Blow*, starring Johnny Depp as George Jung. The film's title comes from a slang term for cocaine. In any event, his capture serves as a

reminder that smugglers may amass fabulous wealth, but there are severe consequences if they are caught.

Why are we so fascinated by pirates? They appear to be mysterious, sometimes ruthless characters who go after what they want with impunity. One of the more interesting pirates was ten-year-old John King, who threatened his mother and demanded to join the crew of Captain Sam Bellamy. His stint as a pirate only lasted four months until the *Whydah* went down in 1717. It's possible he worked as a "powder monkey" or someone who carried gunpowder to the cannons aboard ship. Whatever their age or station in life, pirates and smugglers continue to enchant us with their legendary adventures at sea.

THE ARCTIC EXPLORER FROM PROVINCETOWN

Cape Cod is home to many hardy, far-sighted individuals who shaped its history. One such influential person was the intrepid explorer, sailor and researcher Donald Baxter MacMillan.

Born in Provincetown on November 10, 1874, MacMillan is remembered as one of the great American explorers and got his calling early. At age nine, his father was lost at sea in Newfoundland while captaining a Grand Banks fishing schooner. His mother, with five young children to care for, took in washing to support them and died three years later. MacMillan was taken in by a woman whose husband had also been lost at sea. Then when he was thirteen, MacMillan's newly married sister took him to live with her in Freeport, Maine. He graduated with a degree in geology from Bowdoin College in 1898.

After college, MacMillan became a teacher of Latin making $500 yearly. He was appointed as the principal at the high school in Gorham, Maine, and then headed the classics department at Swathmore Preparatory School in Pennsylvania. After this, he joined the faculty at Worcester Academy, in charge of athletics. He also started the first nautical camp in America on Maine's Casco Bay. One of the campers was Cole Porter, who would go on to become a famous composer and songwriter. Nearby, on Eagle Island, was the summer home of Admiral Robert E. Peary, the famous explorer who reached the geographic North Pole on April 6, 1909.

While at camp, Donald Baxter MacMillan helped rescue six people from an overturned yacht. Two nights later, he again helped rescue boaters in

distress. The Portland papers paid tribute to his bravery. One person who was impressed by his valor was Admiral Peary. In 1905, Peary wired MacMillan: "Have chance for you on North Pole trip." Perhaps because his father had been lost at sea, he wired back, "Sorry. Impossible." He had also signed a contract with Worcester Academy and didn't want to break the agreement.

In 1908, Peary asked MacMillan for a second time to accompany him to the North Pole. This time, he caught the train to New York. Peary, at age fifty-three, told MacMillan that this would be his last attempt at the Pole. On this first trip, MacMillan had to turn back because of frozen heels, while Peary continued on and reached the North Pole twenty-six days later. MacMillan's next step was to organize his own expedition to Greenland in 1913, and he became stranded there. Peary maintained he had seen a mysterious landmass north of Greenland, but it turned out to be a mirage. MacMillan wouldn't be rescued until 1917. It was during this time that he developed the idea for a boat that would be easy to maneuver through ice and would be ideal for Arctic travel.

On his return home, the United States had entered World War I and MacMillan joined the navy. At the end of the war, MacMillan began building a ship to be used for further Arctic research. He took a position at Bowdoin College teaching anthropology and making trips north during the early part of the 1920s on his specially designed vessel, the *Bowdoin*. He led expeditions to Greenland, Labrador and Baffin Island in 1926 and 1927–28. Later in life, according to a *Cape Cod Standard Times* news article from 1957, when asked why he felt a calling to study the north, he said "[I had] the desire to learn." In all, he would take thirty-one polar expeditions.

MacMillan married Miriam Norton Look, the daughter of his longtime friends Jeremy and Amy Look, on March 18, 1935. Initially, MacMillan didn't want his new wife to accompany him on his trips, but she eventually convinced him of her interest and willingness to help in his research. She also spoke at her husband's many lecture tours. Over the next fifteen years, he studied the Eskimos, their life and language and eventually established a school for Eskimo children in Labrador. When he first encountered the Eskimos, they thought they were the only people in the world. His collaboration with and research of the Eskimo, or Inuit, people would continue through his lifetime. He also surveyed and mapped uncharted lands and took geological specimens in the regions of Labrador and Newfoundland. By 1957, he and his wife had taken 200,000 feet of colored film of their travels.

When World War II began, he rejoined the navy and served in the Hydrographic Office in Washington, D.C. He was promoted to the rank

of commander in 1942. After the war, he commanded Arctic explorations in 1944, 1946 and 1947. In 1944, he received the Congressional Medal of Honor. He was also awarded the Bowdoin Prize in 1954.

MacMillan made his final trip to the Arctic in 1957 at the age of eighty-two. He died on September 7, 1970, and is buried in Provincetown. After his death, Miriam catalogued thousands of slides, photographs and artifacts they had brought back from the Arctic. She died on August 18, 1987, and is also buried in Provincetown. The main pier in Provincetown is named for MacMillan.

FANTASTIC CREATURES

Cape Cod is home to many interesting creatures, some familiar and some not so much. Coyotes are a common sight, especially for residents who live near woodlands and fields. Wild turkeys proliferate in the autumn months. Many motorists have had to wait patiently as a family of turkeys slowly ambles across one of the many back roads. There have even been sightings of the elusive fisher cat. The fisher cat, only found in North America, is a marten and related to the family of weasels. It is a ferocious predator, and the sounds it makes are similar to a child or a woman crying for help.

In the old lore of this area are more fantastic accounts of weird animals and amazing sea creatures. Cape Codders have always had an uneasy alliance with the wild creatures in their midst. Some are probably imaginary, while others are very real and seem to take living with humans in stride.

A LONG AGO SEA SERPENT

One fantastic sighting occurred in 1886, when the Provincetown town crier, George Washington Ready, saw a huge creature rise out of the surf as he was walking over the Province Lands dunes one morning. In a news report of the time, Ready said, "It was 300 feet long, more or less! Had a head as big as a 200-gallon cask! Six eyes, as large as good-sized dinner plates that rose from

the body." Since Ready was hiding behind a sand dune, he was able to study the creature. According to Ready, it had "a mouth that disclosed four great rows of teeth and a tusk that extended from the nose at least eight feet." He also described its terrible sulphurous scent and intense heat that seemed to scorch the surrounding terrain.

Many newspapers of the day published accounts of this rare sighting. The June 26, 1910 *New York Times* carried an article entitled "Provincetown; Capt. Ready Is Ready with his Regular Sea Serpent Tale." An article published in the *Cape Cod Times* in 1992 by Hamilton Kahn references an even earlier sighting in Provincetown. A fleet of shore-whalemen in 1719 confronted an "unidentified, large species." An eyewitness account by B. Franklin, an uncle of Ben Franklin, saw a creature sixteen feet long, with a long beard and short yellowish tail, which "fled to deep water after being wounded three times by the whalers' harpoons."

THE PAMET PUMA: TRURO'S MYSTERIOUS CREATURE

In the late fall of 1981, animals started disappearing from around North Truro. First chickens, then cats. Later, the local dog officer found cat carcasses, some with missing heads, in a wooded area near the Governor Prence Motel. In the weeks following these first disappearances, a wild dog and several deer were found ravaged. Something was out there, something scary.

In a *Cape Cod Times* article, reporter Gayle Fee wrote, "A North Truro accountant puts out his large tom cat one night, hears a scream, and his beloved pet is never seen again. Several days later, he sees a large, brown, fast-moving cat-like animal streaking through his pasture. He checks out the tracks and finds 'they are all claw.' A few days later, a 150-pound boar is discovered in such bad shape that it has to be slaughtered. The creature suspected of killing local animals is dubbed the 'Pamet Puma.'"

Some theories about what the elusive creature could be included a dog, a Bengal tiger, a mountain lion or a bobcat. Some witnesses thought the creature was the size of a large German shepherd dog and weighed sixty to eighty pounds. The Truro dog officer at that time, Mark Peters, said, "I feel a little like Chief Brody in *Jaws*. For months I've been saying there's something wrong here. I don't want to sound like I have a siege mentality, but there is

cause for concern." The story spread, and soon news teams from Boston came to find the truth about Truro's mysterious creature. A local animal trainer even offered to help find and trap the animal.

Once the winter came, rumors of the "puma" faded. Still, Cape Codders haven't forgotten the tale. Even though experts concluded that the animal didn't exist and the killings were the work of dogs, it's always possible that someday the sightings along the Pamet moors will return.

HORDES OF SEALS

In the spring of 1900, there was a rare sighting of seals in Brewster. One headline read, "The dunes were black with seals." A lighthouse keeper's daughter was quoted as saying that "the most unusual thing I remember were the hordes of seals on the dunes of the outer beach. We would walk over there and the beach was sometimes, it seems, just black with them. They would see us and begin barking."

Cape Cod is home to hundreds of seals. Over forty years ago, Massachusetts paid a bounty to hunters for killing seals because it was

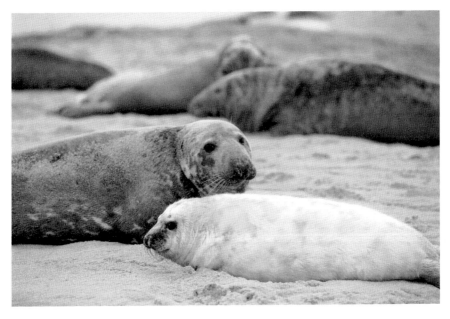

A herd of gray seals off of Monomoy Island, Chatham. *Courtesy of the* Cape Cod Times.

thought that seals were having a large impact on fish stocks. According to recent studies, Cape Cod now has the largest number of gray seals on the East Coast, possibly as many as ten thousand to twelve thousand. There is speculation that the large numbers of sharks seen in more recent times are due to the ever-growing seal population. In June 2008, passengers in a seal watch boat out of Chatham saw a shark attack and kill a seal during a cruise to Monomoy Island.

Seals, however, remain of great interest to Cape visitors. Several winters ago, a young harbor seal broke into a Sandwich fish hatchery. It feasted on countless trout before it was captured and released into the waters off a Dennis beach. During the summer months, seals can be seen basking in the sun off the coasts of Chatham and Monomoy. For now, seals are part of the fabric of Cape life.

AN OLD CROW STORY

Crows have been getting a lot of attention lately. A few years ago, federal scientists were working at the Cape Cod National Seashore to plan a way to poison crows in order to protect piping plovers. Crows are often seen as a nuisance bird despite or perhaps because of their cunning and intelligence.

Back in the early 1700s, local farmers had troubles from crows as well. Crows and blackbirds destroyed corn crops. In Truro, around 1711, it was voted "that whereas crows and blackbirds do much damage by pulling up and destroying young corn, every housekeeper shall bring, or cause to be brought between the middle of March and the last day of June, to the selectmen, 8 blackbirds' heads, 2 crows' heads, or forfeit (money) to the use of the poor, and that for additional heads a bounty be paid."

Eastham was even harder on its adult population. It passed an order that "every single man in the township should kill 6 blackbirds or three crows, and shall not be married till they comply with this requisition." Imagine a marriage not taking place because the groom didn't present his gathering of dead birds!

CAT'S ALLEY

In Bass River in South Yarmouth lies Pleasant Street. At one time, this was called "Cat's Alley" for its preponderance of felines. Since the town wharf

abutted Pleasant Street, the place was lively with commercial fishing activity. Cats were even known to block traffic in their pursuit of tasty bits of fish. In an interesting twist, the street was also home to the Owl Club, a social club for men, and situated in a house built in 1827 by Daniel Wing. It was said the club got its name because a member's wife said the men were worse than night owls.

Other Animal Sightings

Other animals that posed a nuisance were foxes, wolves and deer. In 1713, Eastham passed a law that three pounds' bounty would be paid for every head of a grown wolf. There was even talk at this time of putting up a high fence somewhere in the location of what is now the Cape Cod Canal to keep the critters out. The gray wolf was hunted to extinction by the mid 1800s; however, they may be reappearing in New England. In October 2007, a wolf was shot in a rural area of northern Massachusetts. There was also a confirmed wolf sighting in Maine in 1993. Some scientists speculate that the recovering Eastern Canadian population of gray wolves is moving south.

Presently, another predator posing as a threat to piping plovers is the coyote. At times, they have been shot or poisoned to keep their numbers down. In her book *The Nature of Cape Cod*, author Beth Schwarzman wrote, "Coyotes are relatively recent arrivals on the Cape, having been known to breed here only since the early 1980's." For better or worse, coyotes are now a visible presence on Cape Cod.

Around Memorial Day 2012, a two-year-old black bear, weighing about 180 pounds, made its appearance on Cape Cod. For seventeen days, he traversed the lower Cape, finally making his way to Provincetown. It was the first bear to appear here in around 175 years. He was finally darted in Wellfleet on June 11 and taken to Douglas State Park. It was theorized that he swam the canal or possibly ambled over one of the bridges. The "Cape Cod Bear" captured the hearts and imaginations of local residents and tourists.

These stories confirm that Cape Cod is attractive to many types of animals and marine life. From the fictional shark of *Jaws* fame to the shy black bear, sightings will continue to amaze, terrify and mystify travelers to these shores.

MURDER MOST FOUL

We often look back fondly on the "good old days," but Cape Cod wasn't always a place of innocence. One notorious murder dates back to 1915. When I first researched murders and attempted murders on Cape Cod, I was quite curious about this early crime. The news account was kept in an old clip file with the words, "Very delicate condition. Please handle carefully."

On March 18, 1915, Elliott Wixon, twenty-one years old, was taken to the Barnstable jail and charged with the murder of Winnie Cahoon, also twenty-one. State officer E. Bradford stated that after hearing that a possible murder had been committed in West Dennis, he "jumped into an automobile and fairly flew across the Bass River Bridge to the locality." He and a fellow officer drove across a field and found a man with a smoking revolver in his hand. The two officers were able to disarm him and load him into their vehicle. Later, Wixon would tell Bradford that Cahoon had "picked on him, cuffed and plagued him since [he was] a child. He would never let up. I wanted to get even with him, that's why I did it."

According to eyewitness Frank Chase, he had gone with Wixon and Cahoon into a swamp. Initially, Wixon wanted Cahoon to tie Chase to a tree, saying, "I've got you both where I want you now." After Cahoon refused to do this, Wixon said to him, "Will you take back those words?" Cahoon said, "I will not." Then, in Chase's words, "Wixon placed the muzzle of a 32-caliber revolver at Cahoon's head and fired, killing him instantly." Chase reported that Wixon fired at him but he was able to run away from the

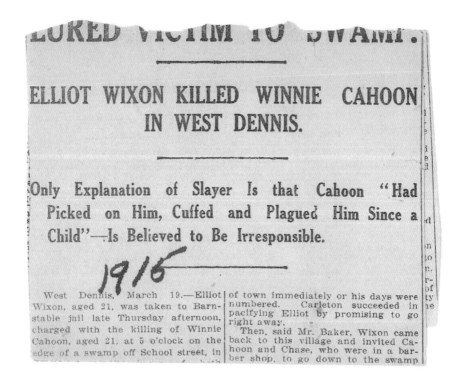

LORED VICTIM TO SWAMP.

ELLIOT WIXON KILLED WINNIE CAHOON IN WEST DENNIS.

Only Explanation of Slayer Is that Cahoon "Had Picked on Him, Cuffed and Plagued Him Since a Child"—Is Believed to Be Irresponsible.

1915

West Dennis, March 19.—Elliot Wixon, aged 21, was taken to Barnstable jail late Thursday afternoon, charged with the killing of Winnie Cahoon, aged 21, at 5 o'clock on the edge of a swamp off School street, in

of town immediately or his days were numbered. Carleton succeeded in pacifying Elliot by promising to go right away.

Then, said Mr. Baker, Wixon came back to this village and invited Cahoon and Chase, who were in a barber shop, to go down to the swamp

A 1915 news article announcing the brutal murder of Winnie Cahoon in Dennis. *Special to the* New Bedford Standard Times.

bullets. It later turned out that Wixon also had a grudge against Frank Chase for killing his cat when the two were boys. It was believed that Wixon had also threatened his brother Carleton with the gun and invited the two men for a drink. Apparently, he had already hidden two quarts of whiskey and brandy in the swamp where he planned to ambush his friends.

The murder shocked local Cape Codders. On October 26, 1915, Wixon was sentenced to life in prison. Since it was the first murder case in Barnstable County in eleven years, it attracted statewide attention. Later, in 1944, the State Executive Council commuted Wixon's life sentence to thirty years.

Although this crime is notable for its violence and the age of the victim and perpetrators, there have been other sensational trials on Cape Cod in the last century. One of the most famous trials was that of Nurse "Jolly" Jane Toppan in 1902. She confessed to murdering thirty-one people before her trial for the killing of Mary Gibbs, the wife of a sea captain. She was accused of murdering an entire family by poisoning them and was arrested on October 26, 1901. Her trial took place in the Barnstable Superior Courthouse. On

June 23, 1902, she was found not guilty by reason of insanity and sentenced to life imprisonment in the Taunton Insane Hospital. She died in the 1930s.

One fascinating case was the grisly murder of twenty-five-year-old Ruth McGurk of Onset. She disappeared after leaving a dance hall on July 27, 1946. Her half-nude body was later discovered floating in Gibbs Reservoir in South Carver. The prime suspect in her murder was Charles Goodale, twenty-four, of Onset. On August 29, 1946, a special session of the Plymouth County Grand Jury met to hear the state's case against Goodale. A

Ruth McGurk Murder in Onset Still Unsolved
On 10th Anniversary of Killing, Sensational Trial

Special to The Standard-Times

WAREHAM, Sept. 1—Couples swayed, bent, spun, their heads bobbing choppily up and down, as the band played, "The Gypsy," "Embracable You," "To Each His Own"—the hit songs of the Summer of 1946.

The girl in the pink dress detached herself from her partner and walked across the dance floor. She stopped beside two girls and said, "I'm going out with Frank. I'll be home early. Wait up for me."

Then she turned and rejoined her partner. They walked out the door of Onset's Colonial Casino dance hall. It was the last time slender, 25-year-old Ruth McGurk was seen alive.

Waited All Night

The two girl friends, who had come to Onset from Cambridge for a two-week vacation with the attractive department store worker, waited for her all night. The next day they informed their landlady that Ruth had not returned. The landlady phoned around for an hour, finally called the Wareham police.

That was on Sunday. The next day the hunt began and the girl's disappearance was made public. Four days later, in the midst of a great air, sea and land search, a cranberry company foreman found Ruth McGurk's half-nude body floating in Gibbs Reservoir in South Carver, 8 miles from the Colonial Casino dance hall. The girl's pink dress and slip were pulled over her shoulders, leaving the rest of her body exposed. Some of her undergarments were missing and others were in shreds. Examination showed she had been criminally assaulted and choked to death. Several teeth were knocked out, her body was black with bruises. Everything indicated she had put up a terrific struggle.

An autopsy showed she was in the water four days. Police theorized she had met with severe torture and death an hour or two after she left the dance hall with "Frank."

Suspects Quizzed

Who was "Frank?" Was he the

RUTH McGURK

CHARLES GOODALE

fiend who criminally assaulted and then strangled to death the pretty brunette?

One suspect was questioned at police headquarters at Wareham's Town Hall and released. Two others were quizzed by investigators and released. The hunt spread to Dighton, Somerset and even Rhode Island.

On Aug. 4, eight days after the slaying, police brought in the person they termed "the No. 1 Suspect"—Charles Russell Goodale of Onset. He was grilled for 24 hours and ordered held by county authorities as a suspicious person in connection with the murder of Ruth McGurk.

Goodale was at the Colonial Casino the night of the slaying and admitted leaving with a girl. She was not Ruth McGurk, however, he said. She was known to him only as "Chum" and he said he dropped her off in Onset later in the evening after they had visited Buzzards Bay night spots. "Chum" never came forward to help him during his trial.

Grand Jury Met

On Aug. 29, 1946, just about 10 years ago, a special session of the Plymouth County Grand Jury met to hear the State's case against the 25-year-old Goodale. The next day it returned a two-count first-degree murder indictment against the Onset man.

A succession of motions, mental tests demands and arguments again and again delayed the start of one of the most famous murder trials in the history of Massachusetts. Finally, on Feb. 5, 1947, after a sanity report on Goodale had been filed, the Superior Court trial began on May 12.

On May 26, as the trial entered its third week, Goodale took the stand, testified for four hours and asserted, "No, I did not kill Ruth McGurk." The 14-man jury agreed with him. Three days later it returned a verdict of innocent.

Charles Russell Goodale, now 35, reportedly is married and living in Florida.

His defense attorney, Herbert F. Callahan of Boston, acknowledged as one of the greatest legal minds in the history of the Massachusetts bar, is dead.

There has been no announced police action in the case since the close of the trial. The mystery remains unsolved.

The sensational headline on the tenth anniversary of Ruth McGurk's murder. *Special to the Cape Cod Standard Times.*

succession of motions, mental test demands and arguments delayed the start of this famous Massachusetts murder trial. Finally, on February 5, 1947, the trial began. As the trial entered its third week, Goodale took the stand and testified on his own behalf for four hours. The fourteen-man jury found him innocent.

A more recent trial that continues to fascinate crime aficiandos is the trial of Antone "Tony" Costa, a twenty-four-year-old Provincetown carpenter. In 1969, he was accused and later convicted of killing Mary Ann Wysocki and Patricia Walsh, both of Providence, Rhode Island. Their dismembered bodies were discovered in the town of Truro in shallow graves, along with the bodies of Susan Perry of Provincetown and Sydney Monzon of Eastham. After his murder trial wrapped up, Costa was sentenced to the Massachusetts Correctional Institution at Walpole. He was found hanging in his cell in May 1974. In 1981, author Leo Damore published his book *In His Garden* about the Costa case.

Another case that gripped the attention of Cape Codders was the murder of fashion writer Christa Worthington in Truro. Her body was discovered on January 6, 2002. She had been stabbed and sexually assaulted. Her two-year-old daughter, Ava, was found unharmed by the side of her forty-six-year-old

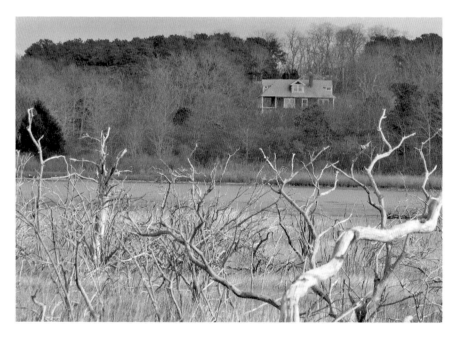

Christa Worthington's home in Truro, the place where her body was discovered in 2002. *Courtesy of the* Cape Cod Times.

mother. There was speculation that her body had remained undiscovered for up to two days.

Initially, suspicion fell on Tony Jackett, the local shellfish constable, and father to Ava. He was also married with a large family. Later, Christa's garbage collector, Christopher McCowan, was charged with the murder. He was found guilty of first-degree murder, burglary and rape in Barnstable

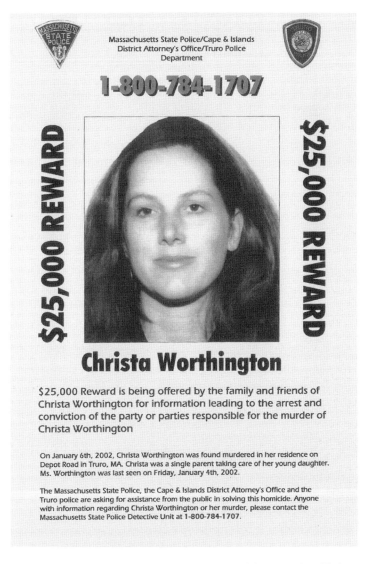

Massachusetts State Police/Cape & Islands
District Attorney's Office/Truro Police
Department

1-800-784-1707

$25,000 REWARD $25,000 REWARD

Christa Worthington

$25,000 Reward is being offered by the family and friends of Christa Worthington for information leading to the arrest and conviction of the party or parties responsible for the murder of Christa Worthington

On January 6th, 2002, Christa Worthington was found murdered in her residence on Depot Road in Truro, MA. Christa was a single parent taking care of her young daughter. Ms. Worthington was last seen on Friday, January 4th, 2002.

The Massachusetts State Police, the Cape & Islands District Attorney's Office and the Truro police are asking for assistance from the public in solving this homicide. Anyone with information regarding Christa Worthington or her murder, please contact the Massachusetts State Police Detective Unit at 1-800-784-1707.

A Wellfleet police handout seeking the murderer of fashion writer Christa Worthington. *Courtesy of the* Cape Cod Times.

Superior Court on November 16, 2006, and sentenced to life in prison without parole. Local author Maria Flook wrote *Invisible Eden: A Story of Love and Murder on Cape Cod* about Christa's murder and its aftermath.

One sensational murder was that of sixteen-year-old Jordan Mendes. His body was found in a shallow hole on December 16, 2008, in Hyannis. He had been shot, stabbed and burned. According to a news report in the *Barnstable Patriot*, Mendes had been shot once in the torso and stabbed twenty-seven times before his body was dumped in a hole and burned. His alleged attacker was Robert Vacher, twenty-two, of South Yarmouth, and Vacher's accomplices were Mykel Mendes (Jordan's half-brother) and Kevin Ribeiro. The two younger boys were thirteen at the time of the murder. It appears that greed was the cause of the killing. The three men stole a large amount of oxycodone. They also took $10,000 in drug money from Mendes, which they later used to buy a BMW.

Vacher was indicted for murder, armed robbery and assault and battery with a dangerous weapon. Mykel Mendes and Ribeiro, now both fifteen, were also charged with the murder under the legal theory that it was a joint crime. Vacher was held without bail at the Plymouth County Correctional Facility while the teens were both placed at the Department of Youth Services facility in Taunton. On November 30, 2011, Vacher was found guilty of murder after a three-week trial and sentenced to life in prison without parole. The younger boys were to be held in jail until they turned eighteen.

Although Cape Cod is a haven for tourists, artists and nature lovers, it has also been a place for unspeakable and unlawful acts. Murder most horrid, indeed.

GENTLE LEGENDS

People who live on Cape Cod are used to visitors; however, in the nineteenth century, three famous women graced our shores. The first, Helen Keller, an American author, lecturer and political activist, gained worldwide recognition for becoming successful while being both deaf and blind. Born in 1880 in Tuscumbia, Alabama, Helen was a normal child but lost her senses of sight and hearing after an illness at nineteen months. When Helen was seven years old, her parents brought a teacher, Annie Sullivan, from Boston to be Helen's instructor. They would stay together for the next forty-nine years with Annie becoming Helen's companion in later years.

The second well-known visitor was the Swedish opera singer Jenny Lind. She was one of the most highly regarded singers of the nineteenth century. Born in 1820, she performed soprano roles in Sweden and across Europe. In 1843, she toured Denmark, and it was there that she met Hans Christian Anderson. He fell in love with her, but she didn't reciprocate his feelings. She began a popular concert tour in America in 1850 at the invitation of P.T. Barnum. It was a hugely profitable tour, and Jenny was able to return home to Sweden with her new husband, Otto Goldschmidt, in 1852. They raised three children while she continued to give occasional concerts.

Another famous woman who visited and appeared in plays at area theaters during her eighty years of acting was the versatile Helen Hayes. Born in 1900, she starred in her first Broadway play at age eight and became friendly with many famous actors and actresses of the time. At age seventeen, she played in *Pollyanna* and received much media acclaim for her performance.

A quaint postcard depicting Jenny Lind singing to Hans Christian Anderson. *From the postcard collection of Wendell E. Smith.*

After her marriage to Charles MacArthur, she moved to Hollywood. She won an Academy Award for her first film, *The Sin of Madelon Claudet*. Her great love was the theater, and she returned to Broadway in the 1930s. Roles that made her famous included *Mary of Scotland* and the role of Queen Victoria in *Victoria Regina*. She retired from the stage in 1971 but continued her acting career in film and television. She died of congestive heart failure in 1993. Here are the stories of these three renowned women and their respective visits to Cape Cod.

HELEN KELLER'S CAPE CONNECTION

Recently, the Cape and Boston papers were abuzz with news that a photo had surfaced showing Helen Keller and Anne Sullivan vacationing in Brewster in 1888. At the time the picture was taken, Helen was eight years old. In the photo, she appears sitting next to her new teacher and holding a doll. The photo was given to the New England Historic Genealogical Society by Thaxter Spencer, eighty-seven, of Waltham, who donated family memorabilia for preservation. There is evidence that the photo was taken outdoors at Elijah Cobb's house because Spencer's mother, Hope Thaxter Parks, often stayed at the Cobb house during summers as a child.

Regardless of how and why the photo surfaced, it makes a fascinating story. For a little girl who lacked both sight and sound, it must have been a remarkable experience to visit the Cape's sandy beaches, smell the salt air and touch the small marine creatures when the tide went out. According to an Associated Press (AP) article, "Spencer, who doesn't know which of his relatives took the picture, told the society that his mother, four years younger than Helen, remembered Helen exploring her face with her hands." It's also possible that those visits solidified the relationship between Annie and Helen since they had only recently started their lifelong journey as teacher and pupil.

In Helen Keller's autobiography, *The Story of My Life*, she alludes to her Brewster visit: "I also remember the beach [in Boston], where for the first time I played in the sand. It was hard, smooth sand, very different from the loose, sharp sand, mingled with kelp and shells, at Brewster."

On a personal note, my parents, Muriel and Wendell Smith, former owners of the Incredible Barn Antiques and Book Shop in East Orleans, once saw the guest register

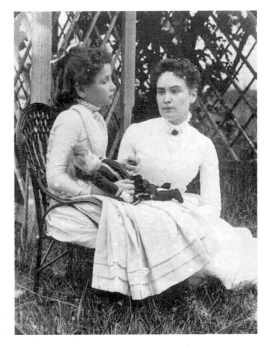

Helen Keller and Annie Sullivan in Brewster, circa 1888. *Courtesy of the New England Genealogical Society.*

39

for a Brewster guest house where Helen Keller and her companion, Anne Sullivan, stayed. It belonged to friends who had family who owned the guest house on Briar Lane. In this register were the names of Helen Keller and Anne Sullivan and signed by Anne (or Annie) Sullivan. This is more proof that the famous pair did indeed visit Cape Cod.

THE LEGEND OF THE JENNY LIND TOWER

In North Truro, there is an odd stone tower that is affectionately called the Jenny Lind Tower. It is near the Highland Light, a lighthouse situated on a cliff overlooking the Atlantic Ocean. It was in this lonely spot, as legend goes, that a tower was built to commemorate a beautiful and memorable songstress. Johanna Maria Lind was a famous Swedish opera singer. "The Swedish Nightingale" was brought to this country by American showman P.T. Barnum and toured here for several years.

In 1850, she came to Boston to give a concert, and the event was so well attended that many theatergoers had to wait outside in the street. The resulting outcry came to Lind's attention, so she climbed to the top of one of the towers of the Fitchburg depot (the name for the Boston and Maine station) and sang to the crowd below. One man who was enchanted by Jenny's singing was a prominent Boston attorney, Harry Aldrich. When the old depot was demolished in 1927, Aldrich bought the tower and had it shipped piece by piece to Truro, and there it was rebuilt on the property belonging to the Aldrich family. Today, it is owned by the Cape Cod National Seashore.

An alternate story is that Jenny Lind, although she sang at the Boston concert and it was cut short due to overcrowding, never sang from the tower. Newspapers of the day didn't report this, and so the story appears more rumor than fact. Some speculate that Aldrich moved the tower to Truro because he was in love with Lind and wanted to memorialize her beautiful voice. The seventy-foot tower is solid granite and lined with bricks. There are no roads to the tower although there is a road nearby that leads to the North Truro Air Station.

Whichever version of the story is true, there remains a haunting beauty in the legend. It is speculated that Jenny Lind still resides in the tower, and on a summer's evening, visitors can hear the lilting sound of her melodies serenading them over the dunes.

A bird's-eye view of the Jenny Lind Tower in Truro, Massachusetts. *Courtesy of the* Cape Cod Times.

THE FIRST LADY OF THE AMERICAN THEATER

In November 1979, Helen Hayes, often called "the first lady of the American Theater," spoke at the Unitarian Universalist church in Provincetown. She was part of a ceremony to announce the architect chosen to design the new Provincetown Playhouse on the Wharf and the Eugene O'Neill Archival Center. As reported in an article by Anne LeClaire, Helen Hayes told the assembled crowd, "History, drama, architecture and Provincetown will all be enriched by your venture here."

Tiny and gracious, Helen had pixie charm. The church was full of fans and well-wishers. She spoke that day about her mother buying tickets to the winter series of Eugene O'Neill's plays and falling in love with theater and Cape Cod. She was fortunate to visit Cape Cod many times. In her *Cape Cod Times* biographical file, there are numerous articles about her days appearing at the Falmouth Playhouse. In a 1947 article, Hayes talked about seeing her first cranberry bog and eating the "best ice cream in the world" with her best friend Lillian Gish. She appeared in several plays at the playhouse, including *Mary of Scotland, The Wisteria Tree* and *Mrs. McThing*. There are weathered photos showing her in her dressing room or posing with her husband, Charles MacArthur, at the Hyannis Airport before flying back to New York.

Helen Hayes was one of only twelve people to have won an Emmy, a Grammy, an Oscar and a Tony award. Her theater career spanned almost seventy years. In fact, she had her first role when she was five years old. She appeared on stage and in films. Her life was touched by tragedy, however, when her only daughter, Mary, died of polio at age nineteen. Mary had been following in her mother's footsteps by appearing in plays at both the Cape Playhouse in Dennis and the Falmouth Playhouse. Several years later, Helen's husband died. She wrote about her life in her autobiography, *My Life in Three Acts*.

Many illustrious actors and actresses have graced the stages of Cape Cod, but Helen Hayes was an original. She died in 1993 at the age of ninety-two in Nyack, New York. It was an honor that Provincetown residents and guests were able to hear her speak about her long life devoted to the theater.

THE DISAPPEARANCE OF BILLINGSGATE ISLAND

B illingsgate, an island that stretched from Orleans to Truro, was once home to thirty homes, a school, a lighthouse and even had its own baseball team. The island covered fifty acres and for many years was under the jurisdiction of Eastham. The island was sometimes called the Cape's "mini-Atlantis." Originally, all of Wellfleet was known as "Billingsgate" after London's famous fish market district because the waters were so rich with fish and oysters. In 1763, the town declared itself as the "town of Wellfleet" and the island remained Billingsgate. The chain of islands off Wellfleet also included Bound Brook, Griffith's Island and Great Island. Legend has it that the Pilgrims discovered and explored the island in 1620. Myles Standish is believed to have spent the night. Before colonization, Constance Hopkins, a *Mayflower* passenger, and her husband, Nicholas Snow, were the first-known owners of the island. It came under their control in the 1640s.

In the nineteenth century, the island boasted a fishing village. Men from the mainland would move with their families to the island to fish from early spring until winter. These men weren't "hand-liners" but caught their fish with gill nets, pounds and weirs. This was an important port and the second site on Cape Cod to have a lighthouse. It was constructed in 1822. This was also rich whaling territory, and locals often pursued whales off the island.

Henry David Thoreau, in his writings about Cape Cod, told a story that dates back to 1865. The Billingsgate lighthouse keeper came out one

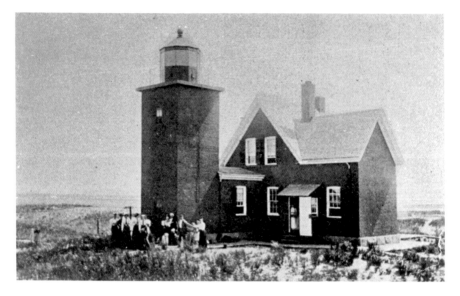

An antique photo showing the island of Billingsgate with its residents posing outside the lighthouse keeper's house and lighthouse. *Courtesy of the W.B. Nickerson Archives, Cape Cod Community College.*

morning to find a fortune in blackfish had "been heaped by the sea right around his lighthouse!" To mark possession of a whale or blackfish, an individual carved his initials on the fish. So the lighthouse keeper initialed every blackfish before anyone else could get to them. He later sold the batch in Provincetown for $1,000. He made more in one day than he could make in an entire year tending the lighthouse. Seals were plentiful, too, and a bounty of $3 was offered for each head.

The life of a lighthouse keeper could be lonely. Once families left the island, the lighthouse keeper might be alone for months at a time. In the book *Three Centuries of the Cape Cod County/Barnstable, Massachusetts/1685 to 1985*, Admont G. Clark, in the chapter on "Lighthouses and Lightships," wrote that Herman Dill, a lighthouse keeper during the 1870s, wrote in his log for March 26, 1876, "The very worst storm for the winter was last night." He was found dead the next day, adrift in his boat.

The first mention of erosion to the island was in 1872 in the lighthouse keeper's log. A seawall was built in 1888 to protect the lighthouse. Even after families moved away from the island (all were gone by about 1912), people still went there to fish. In order for people from the mainland to communicate with those fishing on the island, a bonfire built on Mayo Beach in Wellfleet would summon the fishermen home. The lighthouse was

abandoned in 1910 and later fell to the sea due to the effects of erosion. The last person to live on the island was Emil Poikonen, who spent several years on the island before returning to Finland to marry and run a sawmill.

Dr. Maurice Richardson, a Boston surgeon, bought the island and kept a summer home and a clubhouse for fishermen there. Then, before World War I, Richardson sold the island to Robert S. Barlow of Boston. The island, now measuring about five acres, fell victim to erosion. Some of the homes were taken to mainland Wellfleet as well as bricks from the last lighthouse.

In 1928, the island was made into a bird sanctuary with the help of Dr. Oliver L. Austin Jr., an ornithologist from South Wellfleet. It was finally returned to the state in 1936. Shortly after, in the late '30s or early '40s, the island sank beneath the waves. All that remains now is a sandbar exposed at low tide.

VILLAGE VIGNETTES

There are fifteen towns that make up Cape Cod. From Provincetown to Woods Hole, each town has its own unique flavor and history. Here are a few stories about these special places.

THE ORLEANS HEN HAWKS

A little-known fact about Cape Cod is that in 1911, a group of women called the "Orleans Hen Hawks"—or, more politely, the "Orleans Street Light Club"—founded what may have been the only street lighting system owned by women at the time. Before the Street Light Club came into existence, people mostly carried lanterns at night. The one male associated with the group, Josh Northrup of Rock Harbor, would go up and down the streets of Orleans on moonless nights with a ladder, some oil and matches. He served as the Hen Hawks' lamplighter. If the moon was out, no lamps were lighted, and that's how the group started. They wanted to provide light for their small community on dark nights. Before electricity was introduced, the lamps were mostly gas lamps.

The women got their name because when they needed to raise money, they asked around and solicited a chicken for a community supper. Among its members were Hannah Rogers, Nellie Higgins, Annie Snow, Louise Hurd and Addie Nickerson. Maude Knowles and Lizzie Wilkins, the postmistress,

joined up sometime later. They were members of the Rebekahs, a service-oriented organization affiliated with the Order of Odd Fellows.

The group organized a play, and with the proceeds of $90, they bought twenty-five streetlights and offered to give them to residents who promised to maintain them. They charged twenty-five cents for membership and hired a room over an old theater and used the space as a workshop to make items to sell. They also put on suppers to make money. At their peak, the group had $2,500 in the bank. The oldest member of the group, Addie Nickerson, died at age ninety-six in 1955. The first electric lights in town were put up by Henry Coffin for the Cape and Vineyard Electric Company sometime after 1916.

THE BUSINESS BOOM IN BREWSTER

In 1663, Thomas Prence, governor of the Plymouth colony, built a gristmill in an area known as Stony Brook that would later become part of Brewster. In fact, business in Brewster revolved around water from the seventeenth through the nineteenth centuries. The gristmill was built to help preserve Indian corn. The corn was ground by pounding it with a stone, but when that method was deemed too slow, the answer was a mill. A few years later, the mill was sold by Prence to one of the founding families of Brewster, the Clarks. It was the first water-powered gristmill and woolen mill in the country.

Many other businesses sprang up, and Brewster became a factory village that included the forerunner of the United Shoe Company of Boston. Eventually, some of the businesses brought ecological problems with the stench of tanneries and slaughterhouses. There were also odd-looking vats that dotted the shores for saltwater evaporation. The salt left behind was packed in barrels and sent to Boston and Gloucester, where it was used to preserve fish.

A British gunboat threatened Brewster's livelihood during the War of 1812, so the town paid a ransom of $4,000. It was a small price to pay to save the saltworks. In the 1800s, numerous local men left to make a living on the sea, with many sea captains of the day hailing from Brewster. They left home around the age of twelve, shipped out on Brewster packets where they headed for thriving ports and a chance to sign up on ocean-bound sailing ships.

Finally, when other businesses faded away, tourism came to the forefront. In 1926, Cordelia Keith founded the Funcroft Inn; its name was later changed to Elm Tree Inn. This was a place for tourists to relax, try golf and tennis or spend the day on a nearby beach. Many old sea captains' homes became inns such as Crosby Mansion and the Captain Freeman Inn. The many beautiful beaches in Brewster include Linnell Landing and Points of Rock Landing. Brewster is also home to Nickerson State Park.

What's in a Name?

The original name for Chatham, located on the elbow of Cape Cod, was Monomoyick. Early French navigator Samuel de Champlain encountered the Monomoyicks, a Native American tribe of about five hundred to six hundred members, in 1606 during his explorations. The first English settler, William Nickerson, originally from Norwich, England, bought a tract of land from John Quason, chief of the Monomoyick tribe of Indians in the spring of 1665. This Indian name is still preserved for the long sandy point of land that stretches eight miles south of Chatham. Then, in 1672, Nickerson bought another tract of land from Quason and Mattaquason, another chief, in what is now Chatham.

Since these purchases were not authorized by Plymouth Colony, Nickerson came under fire until he cleared the title by acquiring a grant that permitted him to buy from the Indians. More settlers followed Nickerson, including some with such familiar Cape Cod names as Thacher, Rogers, Eldredge, Cahoon, Howes, Atkins, Taylor, Doane, Crowell and others. In 1664, Nickerson settled his family on the west side of Ryder's Cove. On June 11, 1712, Monomoy was incorporated as a township under the name Chatham. The name Chatham is believed named for William Pitt, Earl of Chatham. Before its incorporation as a town, Chatham was under the jurisdiction of Yarmouth, then of Eastham.

One important landmark was the Monomoy Point Lighthouse that stood for nearly a century and was established in 1823. One of the three first lighthouses on Cape Cod, Monomoy was discontinued in 1923. In 1925, the Monomoy reservation, which consisted of the abandoned lighthouse and the lighthouse keeper's home, was sold to George Dunbar of Chatham. In the 1930s, the lighthouse was sold to George S. Bearse, a Chatham auto dealer. His wish was to preserve the lighthouse. The deactivated lighthouse is now located within the Monomoy National Wildlife Refuge.

During the heyday of the great sailing ships, many sea captains amassed comfortable fortunes and brought back beautiful artifacts from places like China and the Mediterranean. Although those days are gone, Chatham is famous for its fishermen. In its early history, striped bass were so plentiful that the early settlers used them to fertilize their fields. In the late 1800s, Chatham began attracting visitors and became a resort area.

ORLEANS, AN EARLY CAPE COD TOWN

Incorporated in 1797, Orleans was originally known as the South Parish of Eastham. However, the town has always highlighted its French connection. Over time, separate theories have developed about how this scenic town got its name. Unlike many Cape Cod towns that have English or Indian origins, Orleans is uniquely French. According to one theory, Louis Philippe, the Duc d'Orleans, may have visited the American Orleans in 1797. In another version, the French town sheltered Orleans captain Issac Snow during the Revolutionary War after his escape from the British. Legend has it that Snow met the Marquis de Lafayette there. This wealthy and well-connected nobleman was out recruiting money and men to fight in the American Revolution and helped Snow return home.

Orleans also has the distinction of being the only U.S. site of attack by the Germans in World War I. A German U-boat fired on the tug *Perth Amboy* and four barges in the Nauset area in July 1918. In 1997, Orleans celebrated its 200th birthday. Then selectman Richard Philbrick and his wife, Jackie, delivered an invitation in person to the mayor of Orleans, France. Bicentennial committee co-chair Mary Kelsey said at the time, "We think the French connection is important." After all, it's all in the name.

TRUE TALES OF TRURO

Truro is often overlooked as the town next to Provincetown, but it has an allure all its own. In fact, half of Truro is part of the Cape Cod National Seashore. Before the town was incorporated on July 27, 1709, it was considered the northernmost part of Eastham. The town population has doubled in two centuries. In 1776, the population was listed as 1,227

inhabitants; in 2000, there were 2,087 people calling Truro home. The lowest population figures occurred in 1925 with only 504 people living there.

The town has seen its share of dramatic events. According to a 1976 *Cape Cod Times* article, "The Memorable Gale of October 3, 1841 had taken such a horrendous toll of mariners that the town teemed with widows and senior citizens—the flower of Pamet youth had been lost at sea." Truro was named after Truro in Cornwall, England, whereas the Indians called this area Pamet or Payomet.

In 1981, the town was besieged by stories concerning the Pamet puma, a mysterious animal killing off pets and livestock. Prior to this, the town was the scene of the grisly Tony Costa murders in 1969. The bodies of four women were found in the town cemetery (or "Costa's Garden" as the site was often called). Truro also gained some notoriety when Tommy Lee Jones's character was exiled there in the first *Men in Black* movie (1997) to serve as the town's postal clerk.

In recent years, historians have shown that the Pilgrims first visited this area before sailing to Plymouth. While there, they discovered what would later be known as Corn Hill. Perhaps because the Pilgrims felt there was a scarcity of water, they moved on. English colonists in 1690 settled what is now Truro. The most popular industries were shipbuilding, fishing and whaling.

Several companies were located here: the Magoun and Sleeper shipyards, the Mercantile Insurance Company and several ship outfitters. The packet boat *Post Bay* made frequent trips across the bay to Boston carrying passengers and light freight. Later, Truro's prosperity faltered with the shoaling of Pamet Harbor and the memorable gale of 1841.

It wasn't until the rise of tourism in the twentieth century that Truro's fortunes shifted. Artists flocked to the town to take advantage of the natural light. At present, many visitors enjoy the beautiful scenery and visit landmarks such as the Jenny Lind Tower and the Cape Cod Highland Lighthouse.

PROVINCETOWN: A THRIVING SALTWORKS INDUSTRY

Provincetown, located at the tip of Cape Cod, was once a thriving fishing port with a fleet of about one hundred schooners. It was also home to a saltworks industry in the 1800s. Windmills were used to supply power for the numerous saltworks that lined the baysides of Provincetown and North

Truro. A saltworks consisted of a windmill that pumped water from the sea into large out-of-door vats. When the sun heated the vats, the water evaporated and left behind salt that Provincetown fishermen depended on to preserve their catches.

George Bryant, the late Cape Cod historian and native of Provincetown, said in a 1978 *Cape Cod Times* article that the saltworks were "a true solar system. It made no noise, used no fuels and caused no odors." He was building a replica of a nineteenth century saltworks at that time. A hollowed-out pine log was used as a "pipe" that would draw sea water. He planned to make the saltworks as authentic as possible. His replica saltworks was constructed, but the windmill he hoped to build was never completed. In Bryant's obituary, it stated that he "researched and collected photographs, artifacts and records of the Provincetown whaling, fishing and salt industries."

The heyday for saltworks was from about 1800 to 1840. Some of the vats were one thousand feet long and were often located blocks from the windmills. Wooden pipes were laid, either above or below ground, to transport salt water to the vats. Since fishing was seasonal, the saltworks only ran during the summer months. Boat owners and fishermen operated the saltworks and often used children and the elderly to help out since the fishermen were out fishing. Families even adopted orphans from Boston to work in the saltworks. Once refrigeration became popular in the nineteenth century, the saltworks were taken down and the wood sold for home construction. The last saltwork was dismantled in 1865.

SHIPBUILDING IN CHATHAM HAS A LONG TRADITION

Long home to sea captains and fishermen, Chatham has also been a place where construction of small seaworthy crafts has gained a foothold. One of the first shipyards, located on Eliphamets Lane, was started in 1934 by F. Spaulding Dunbar (1906–1991). As a child, Dunbar summered in Chatham and spent the rest of the year in Mansfield. He loved saltwater boating, so he came to Chatham when time permitted. His first efforts resulted in the building of seven wooden catabouts. These were designed and built with the help of Horace Reynolds in the latter's barn.

Due to space constrictions, building operations were eventually moved in 1938 to a boat shop, the Mill Pond Boatyard, that featured the building of

pleasure crafts. Dunbar would ultimately build boats for the Stage Harbor Yacht Club. During World War II, he served as an assistant naval architect. After the war, he continued his boatbuilding business with ten or more employees hired on for the summer months.

His designs ranged from the twelve-foot catboat to his *Ocean Pearl*. This sailing boat was designed in Chatham, constructed in Amsterdam and returned to Chatham's Mill Pond. J. Seward Johnson commissioned two of Dunbar's most important boats: the *Ocean Pearl* and the *Sea Goose*. Many of his boats featured tandem centerboards, an innovation for which he is well known. Dunbar died of pneumonia in 1991, but his legacy lives on in the seaworthy boats he built.

BOURNE'S THRIVING CAR WORKS

The Keith Car Manufacturing Company, commonly known as the car works, was a railroad car manufacturing company that played a significant role in Sagamore history from the late 1800s to the early 1900s. Sagamore, a village of Bourne, benefited from the presence of the company. Originally started as a blacksmith shop by enterprising Isaac Keith, who came from New Hampshire to Cape Cod in 1829, the company became a hub of transportation for Sandwich glass in 1848. Keith and his partner, Ezekiel Ryder, built covered wagons but later switched over to building railroad cars in the late 1800s in a mile-long factory.

By the turn of the century, the railroad car manufacturing business employed 1,200 workers. In fact, at one time, it was the largest employer on Cape Cod. Issac Keith died in the early 1900s, and his son, Eben, became head of the company. In 1912, the company was bought by the Standard Steel Car Company. When World War I broke out, the factory rolled out boxcars ordered by France with forty thousand freight cars shipped to Marseilles, France, during the war years.

After the war, the need for boxcars disappeared. The car works closed in 1929, and its buildings were demolished in the mid- to late 1930s. The Cape Cod Canal and bike path cover the area where the factory once stood.

UNSOLVED MYSTERIES

CAPE COD'S COLD CASES

Although television shows like *CSI* and *Cold Case* focus on mysterious crimes, Cape Cod has also seen its share of so-called cold cases. One of the most notorious and as of yet unsolved crimes is often referred to as the case of the "Lady in the Dunes." In July 1974, the body of a woman was discovered in the dunes of Provincetown. In the words of former Provincetown reporter Eric Williams (from a 2006 *Cape Cod Times* article), "The victim's hands had been severed. They were never found. Her head was nearly removed. Investigators determined the woman had been dead anywhere from five days to three weeks. Cause of death, blunt trauma." The murdered woman's identity remains a mystery to this day, and her murderer has never been found.

One puzzling case was the disappearance of Wanda Reine in March 1971. The first wife of now deceased Falmouth trucker Melvin Reine, Wanda simply disappeared after Reine told police he had dropped her off at the Falmouth bus station so she could visit her cousin. Although police spent years investigating whether Reine had anything to do with her disappearance, the case has never been solved. The mystery deepened when Reine's second wife, Shirley, was found shot to death in the garage of her East Falmouth home in May 2006. Although Reine was a patient in Taunton State Hospital at the time of his second wife's death, it is unclear who might have murdered her. Reine had also emerged as a suspect in the 1979 shooting of Falmouth policeman John Busby.

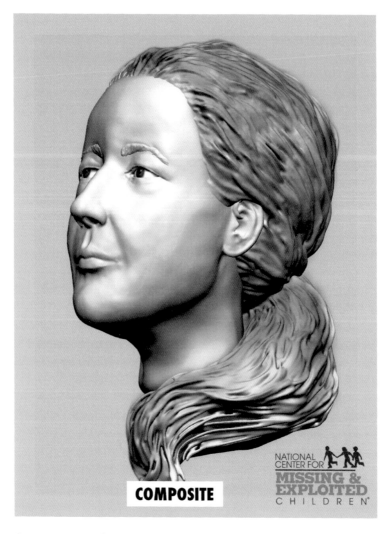

A reconstruction of the head of the Lady of the Dunes. Her decomposed body was discovered in Provincetown in 1974. *Courtesy of the* Cape Cod Times.

Another local cold case was the discovery of the body of fifty-one-year-old Nancy Osbourne in May 1991. The substitute teacher was found bludgeoned to death in the woods near Moody Pond in Mashpee. Osbourne had worked primarily in Boston public schools and at the time of her death was living at the River Bend Motel in Mashpee. She was last seen about three weeks prior to her body being discovered. Again, another crime whose trail has gone cold.

A Strange Disappearance

On April 4, 1978, a thirty-year-old woman, Dorothy Gates, borrowed a wooden dory from a friend's workshop on Little Harbor, Woods Hole. She rowed out into Vineyard Sound. What happened next is a mystery. She may have reached Martha's Vineyard, but we'll never know for sure. What is known is that the dory was found the next day on a West Tisbury Beach. Nearby, there was a cryptic message written in the sand. The strange note read: "Long hours on beach/struggling East." There was an arrow pointing inland next to the word "East."

Who was Dorothy Gates? It is known that she was due to be married in six months' time. In the days following her disappearance, her fiancé, Robert Long, was out looking for her as well as her parents and friends. She was said to be wearing hiking boots, brown corduroy pants and a blue flannel shirt with a torn sleeve. Her friend Godfrey Day, of Falmouth and owner of the dory, said she was a proficient sailor and had rowed as far as the Penikese Islands, twelve miles away. The police were also searching the area. An air and sea search by the Coast Guard turned up nothing. There was little information to go on, and it wasn't clear if the dory had been rowed to its position or had drifted.

According to a *Cape Cod Times* article, state trooper David Flynn of the Oak Bluffs barracks said, "The boat was found on its side at the water line with about 10 inches of water in it. It was not banged up and all the equipment that was in it when it left Woods Hole was in it except for two oars, which were found about 20 feet away." He went on to say "If the boat had capsized, all equipment would have gone with it. And the girl's cap was found in there. If somebody jumped off and set it adrift, it could have floated here."

The search was eventually called off, and Dorothy's loved ones were left with only questions. It's clear that she was an adventurer. A graduate of Vassar College, she once spent three nights in a howling blizzard on top of Mount Washington. Later, on a trip to Africa, she climbed Mount Kilimanjaro. There was some speculation that she set off to think about her upcoming marriage. She also had taken the dory without asking and may have felt badly about that. The disappearance of Dorothy, or "Dory" as her family called her, remains a mystery. What happened to her? Did she make a new identity for herself or simply fade away?

The Case of the Missing Doctor

Another baffling disappearance involved fifty-year-old doctor Margaret Kilcoyne, a researcher at New York's Columbia Presbyterian Hospital. She told friends in the days before her disappearance that she had made a medical discovery that would shed light on the cause of hypertension. On January 26, 1980, she was reported missing from her Nantucket home.

She had traveled from New York to her summer home in order to celebrate her discovery. According to a report from Nantucket's newspaper the *Inquirer and Mirror*, she told a checkout clerk at the local A & P that she might win the Nobel Prize. In anticipation of hosting a party and arranging a press conference to announce her discovery, she bought $650 worth of groceries and $250 worth of alcohol. After having dinner with her brother and some friends, she went back to her Tom Nevers home. Her brother, Lawrence, a vice-president of manufacturing for IBM in Canada, was concerned about her mental state and had come to Nantucket to urge her to get psychiatric help.

The next morning, she was discovered missing by her brother. She left without her winter coat and may have been wearing sandals in the bitterly cold weather. A search operation went into full force over the following weekend, but no signs of Kilcoyne were found. Later, on February 3, a neat pile of her belongings was discovered in an area that had already been thoroughly searched. Found were her wallet with $100 inside, passport, bank book and sandals. Had she left them there deliberately?

In the days following her disappearance, there was speculation that Kilcoyne might have killed herself by drowning. Some speculated that she had flown off the island, but no one at the airport had seen her. Others thought she might have stayed on the island, but she was never seen or heard from again. She was declared legally dead in 1989.

What do these women have in common? Perhaps the fact that they lived in a picturesque place where bad things aren't supposed to happen. If the surrounding landscape of sea and sky holds secrets to terrible crimes, the hints left behind have vanished. Still, in the darkness of a summer's night when we tell stories around a campfire, their chilling tales come back to haunt us.

MEDICAL MALADIES

SMALLPOX CEMETERIES

One of the time-honored pastimes on Cape Cod is graveyard walking. It may sound disquieting, but discovering a little-known cemetery and viewing its old tombstones is a way to connect to the past and also enjoy a meditative hour in a quiet, secluded spot. There are treasures to be found: family plots with the graves of long-ago mothers, fathers and children. Sometimes the deceased were newborns so their stones simply read, "Infant."

Many Cape Cod graveyards are known for their ancient cemeteries with gravestones dating back to before the 1860s. There are also small burying grounds scattered from town to town. These often held smallpox victims. In the 1700s, smallpox was a dreaded disease with no cure. It was also highly infectious. Families buried family members who died of smallpox in separate burial grounds for fear they would still be infected. Even their clothing had to be burned to make sure the disease wouldn't spread. This was a deadly disease that has affected humans for thousands of years. The afflicted would develop high fevers with vomiting, and then eventually the tell-tale blisters appeared that would later scab over. Most of those who contracted the disease died, while those who survived might be disfigured by the pox.

Smallpox burial grounds were known as "pox acres" and are located in isolated places around Cape Cod. These graveyards, some having only a few headstones, can be found from Truro to Chatham, Yarmouth Port to Mashpee. Imagine the dread of losing a loved one to this disease

and then having to find an out-of-the-way place for disposing of a loved one's remains.

One isolated cemetery is located off Comers Road in Chatham. Jim Coogan and Jack Sheedy, in their book *Cape Cod Companion*, mention the smallpox epidemic that started in 1765: the "horror and sadness of those months from December 1765 to March 1766 when ten percent of the town's population contracted the disease. Twenty-four of those infected survived while thirty-seven others died." One of the victims was Dr. Samuel Lord, a heroic doctor who fought to save his patients during the epidemic only to succumb to the disease himself. The town of Chatham erected a marble stone in 1941 to honor him. On the stone is inscribed: "Here lies buried Dr. Samuel Lord who died of smallpox after devoted service to the citizens of Chatham in the epidemic of 1765–1766."

In Truro, deep in the woods, lies the single grave of Thomas Ridley Jr., who died of smallpox in 1776 (he was born in Truro in 1715). It is difficult to locate having been placed in a remote area surrounded by pines and low-lying bushes. There is also an ancient smallpox cemetery in Provincetown with seven tombstones, although fourteen burials are believed to have occurred here. The site had been neglected for years and is now in the hands of the Cape Cod National Seashore.

After the development of a vaccine in 1798 by Edward Jenner, the number of smallpox cases declined. The last recorded death from smallpox occurred in the United Kingdom in 1978.

LEPER COLONY

Penikese Island—located in the Elizabeth Islands, a chain of small islands extending southwest from the southern coast of Cape Cod—is about fifteen miles from Woods Hole. During the early 1900s, the seventy-four-acre island was home to a leper colony. Those stricken with the disease were shunted to this wind-swept island and held there for the rest of their lives. At the time, there were only three leper colonies in the United States, the other two in Louisiana and California. Opened in 1905, those sick from the disease were brought from Tewksbury and Brewster. The colony shut down in 1921, having fifty patients, most of them immigrants.

At the turn of the century, leprosy—or, as it is now known, Hansen's disease—was regarded as incurable and highly contagious, although we

now know it is a treatable condition. In 1904, the State of Massachusetts passed the Massachusetts leper law, stripping lepers of their civil rights. This was also a time when immigrants from Eastern Europe and Asia were more common. People feared they were carrying disease so it was thought prudent to round up known lepers and banish them to Penikese Island. Many of the exiled were from Japan, Greece, Portugal and Russia.

Dr. Frank Parker, a general practitioner from Malden, along with his wife, Marion, headed the colony and tended to its patients. He dedicated sixteen years of his life to treating the victims of leprosy. Four separate cottages were built on the island, along with a laundry and a large building that served as the hospital, office and home to the resident doctor, his family and his assistants. The leper colony had its own boat that brought in food and supplies from New Bedford. The people of Cuttyhunk delivered mail and supplies during emergencies. When help was needed, two signal flags were flown at Penikese.

Dr. Parker worked tirelessly for the welfare of the lepers. After his home was accidentally destroyed by a fire, he moved in with his patients, helping them by growing a vegetable garden, tending dairy cows and pigs, working as a carpenter and electrician and spending his own money to provide for them. During his tenure on the island, many of the patients who died were

The isolated, wind-swept entrance to the leper colony cemetery on Penikese Island. *Courtesy of the Cape Cod Times.*

buried in a cemetery that sits on the highest point of the island. Some of the graves went unnamed, marked only with metal plates. Since the disease was considered highly infectious, workers wore gloves at all times. Used gloves were disposed of by burning them.

The colony was closed in March 1921. Punished for his objections to the closing of the colony, Dr. Parker was denied his final month's pay and a pension, so he moved to Montana, where he died at age seventy in 1926. Nowadays, he is considered the unsung hero of this period in the history of the island. For the people who had been banished to this lonely, isolated place, his presence must have been comforting. In 1994, Massachusetts lawmakers passed a bill that authorized a plaque be placed at the statehouse to celebrate his life and works.

Penikese Island has since been home to an alternative school for troubled boys and a haven for naturalists. All that is left of the leper colony is the lonely cemetery. Kent Hartnett, in a 2005 *Boston Globe* article, wrote, "That burial ground memorializes the unfortunate men and women who lived out their final years in forced isolation from virtually all they knew and loved." This seems a fitting tribute to the brave souls who lost their lives there.

HAUNTED PLACES

There are many famed haunted houses and places on Cape Cod. In fact, virtually every town on Cape Cod can boast a resident ghost. Here is a greatest-hits list of spooky places to read about and even visit.

One of the most famous haunted houses on Cape Cod, the Dillingham house on Main Street in Sandwich, has been written about many times. The house was built in 1650 by Simeon Dillingham in Sagamore and later moved to Sandwich by his grandson, Branch, in 1800. In April 1813, Branch committed suicide, and a few weeks later, his wife, Ruth, died, leaving their nine children orphaned. Accounts of ghostly doings include door latches lifting, empty rocking chairs rocking and the sounds of children running through the house.

Another site of strange happenings is Falmouth's Highfield Hall, an immense mansion with more than twenty-five rooms. Originally built in 1878 by the Beebe family of Boston, the palatial site also featured seven hundred acres of woodlands with walking and carriage trails. Later, in the 1940s, it was used for student actors from Williams and Oberlin Colleges. Over the years, the place fell into disrepair. The town of Falmouth spearheaded a rescue effort and renovation of the historic buildings in 2001. The hauntings are said to have started in the 1950s. A former owner and his friend heard the ghostly sounds of a woman in high heels coming down the main staircase. A few years later, a visitor came after a major hurricane when the electricity was out. He fled after he saw the apparition of a woman lunge down the main staircase toward him.

The impressive exterior of Highfield Hall in Falmouth. *Photo courtesy of Gregory R. Johnson.*

Highfield Hall, one of Cape Cod's haunted places. *Photo courtesy of Gregory R. Johnson.*

There is also the Village Green Inn, located in the heart of Falmouth. There have been many mysterious goings-on reported here over the years. The puzzling image of a man fitting the description of the senior Dr. Edwin Tripp has been seen wandering around the house, where he once practiced medicine. Dr. Tripp, who died in 1953, first bought the house in 1913. In his later years, he was known for his stooped posture and for wearing flannel shirts. It is in this guise that Dr. Tripp is seen by guests as he shuffles down the hall.

The Sagamore Cemetery in Bourne is supposedly haunted by the souls of Cape Codders buried there after they were transplanted from their original graves during the digging of the Cape Cod Canal in 1909. Town residents were upset about the move, and reportedly, one man—Emory Ellis—even stood at the gate of the Bournedale cemetery with a shotgun. Members of the Bourne family whose caskets were moved during the excavation included such luminaries as Jonathan Bourne Sr., father of Jonathan Bourne (for whom the town Bourne is named). In later years, it was reported that mammoth gravestones were moved from their original spots. Sometimes cigar smoke has been detected, lingering in the air. There is speculation that some of the dead were buried under the wrong gravestones, so they may feel unsettled.

One of the hottest spots for ghosts is the Barnstable House on Route 6A. Built in 1716, this place has seen several owners and has been the site of many sightings of different spirits. The most famous is the waiter ghost. He is dressed in old colonial clothes and moves about with a towel over his arm. Captain John Grey, a former owner, is said to slam doors. The house is also known for the "phantom fires" that suddenly appear in the fireplace. Another story about the house is that after responding to a fire there in the 1970s, several firemen reported seeing a woman, dressed in an old-fashioned gown, staring down at them from a third-floor window.

The Beechwood Inn in Barnstable, famed for its period antiques, hosts a resident ghost that is purportedly an older woman in a white dress with grayish white hair. The haunted Rose Room is prime real estate at the inn. Owners and visitors alike have heard footsteps and doors slamming, and doors have even been bolted from the inside.

The amateur ghost hunter might also find good spots for investigation in the Lower Cape. For example, the Burgess House in Brewster has been known as a conduit for ghosts. This was the home of Captain William Burgess, who died of an illness aboard the clipper ship *Challenger* in 1855, and his widow, Hanna Rebecca, who lived another sixty-three years. She remained a widow despite more than fifty proposals of marriage. The current owner hears footsteps and notices artwork is often rearranged.

The Barnstable House, an alleged haunted house, is also known as the House of the Eleven Spirits. *Photo courtesy of Gregory R. Johnson.*

In 2010, members of the Rhode Island–based group of paranormal investigators TAPS (The Atlantic Paranormal Society) team with their own highly rated television show, did a segment on the Orleans Inn. It was built in 1875 by Aaron Snow II for his wife, Mary, and their seven children and is said to be haunted. Once a bustling mercantile center, the place was left empty after William H. Snow, son of Aaron Snow, moved the family business to the center of Orleans. Aaron died in 1892, and the building, known to locals as "Aaron's Folly," remained empty until its purchase in 1900. For the next thirty years, it was run as a boardinghouse. After World War II, it became first a summer and then a year-round hotel. It is here that strange things are reported: lights that go on and off, doors that open and close. Some visitors have heard voices and detected fleeting visual appearances. There are also "cold spots" found inside the building.

At the very tip of Cape Cod, Provincetown has also had its share of haunted houses, including Fairbanks Inn on Bradford Street. This inn, which dates back to 1775, was built by Eben Snow, a sea captain. It was later sold to David Fairbanks in 1826. He began the first Provincetown

banking business in the front parlor of the building. Fairbanks would go on to establish the Seamen's Savings Bank and become the town's wealthiest resident. More recently, the inn began welcoming visitors in 1985 and has a ghostly connection. A Revolutionary War soldier is thought to haunt its fifteen rooms.

The White Horse Inn in Provincetown has a unique history. Mentioned in a *Cape Cod Times* news article, a young woman staying at the White Horse Inn in Provincetown saw a "swirling white presence" during the 1960s. She reported that something breathed on her arm and crumpled the bed sheets. The two-hundred-year-old house is located on the east end of Commercial Street and has also been the site of other hauntings. Customers have reported feeling chilled; in fact, one woman saw the face of an old man. Even the resident cat was spooked.

With its historic homes, inns and even cemeteries, Cape Cod is a great place to explore haunted places. The intrepid ghost hunter, thrilled by apparitions, phantoms and spirits, might make this a spot for further research.

WAMPANOAG TALES

Cape Cod has long been home to the Wampanoag Indians, a Native American Indian tribe. During the early part of the seventeenth century, they lived in what is now southeastern Massachusetts and Rhode Island. Many Wampanoag died between 1615 and 1619 due to disease. Later, during King Philip's War (1675–76), more than 40 percent of the existing Wampanoag tribe perished. Still, members of the tribe survived. The word Wampanoag means "Easterner" or "People of the Dawn."

The Wampanoag hunted and fished with a concentration on the "three sisters": maize, beans and squash. They also supplemented their diet with berries and lived in wetus—dome-shaped huts made of sticks and grass. Wetus were often hot-weather homes set up near summer fishing grounds. The inside of wetus were insulated with bulrush to keep the coolness inside. If the modern-day Cape Codder could step back in time, he or she might glimpse dancers in bright-colored regalia, eagle feathers, a sweat lodge for prayer and a smokehouse for curing fish.

Today there are two federally recognized tribes—the Mashpee Wampanoag Tribe and the Wampanoag Tribe of Gay Head (Aquinnah)—on Martha's Vineyard, totaling about three thousand people. Retaining their culture has been of immense importance, from keeping alive the traditional Mashpee language to providing instruction to school age children. In their native language, Mashpee means "a great river, coming from a pond, bearing many fish." The original name for the Wampanoag language was Massachusett.

A statue of Iyannough, American Indian sachem, located in Hyannis, Massachusetts, at the entrance to the village green. *Photo courtesy of Gregory R. Johnson.*

One of the most well-remembered Native Americans was the sachem Iyannough. He was a native of Cummaquid and a member of the Mattachiest (or Mattakeese) tribe, a sub-group of the Wampanoag. He is best known for his help to the Pilgrims. About eighteen months after the Pilgrims settled in Plymouth, a young boy, John Billington, wandered away from the settlement. He was found by Indians traveling in the area

and sent to Aspintet, the sachem at Nauset. Iyannough was instrumental in returning the boy to the party of men who had been sent out from Plymouth to retrieve him.

The early Wampanoag wore their hair long, either loose or in a braid or a ponytail. Traditional clothing included breech cloth and leggings. Their storied history is steeped in legend and lore. The early Wampanoag tribe had a strictly oral tradition, so many stories were passed down from one generation to the next. The tribe's beliefs center around a love and respect for the land, which according to the Indian way cannot belong to any one person or entity.

One of the most famous stories involved a legendary Wampanoag woman called Granny Squannit (her Indian name was Too-quah-mis-quan-nit). According to Indian legend, she was an old medicine woman who lived alone in a cave. When children were very naughty, they were threatened with a visit from the old woman. In the book *Son of Mashpee: Reflections of Chief Flying Eagle* by Earl Mills Sr. and Alicja Mann, Granny Squannit is described: "She was short, skinny and scary-looking. Her dark hair was long and unkempt, and fell about her face. That dark hair hid her face almost entirely, showing only her narrow mouth and pointed chin. Though no one ever saw her face, everyone was afraid to see it."

One day a young boy pushed some children into a river as Granny Squannit came by in her canoe. She took him to her cave, gave him an herbal potion and he fell into a long sleep. She worked her magic while he slept, but when he woke up, Granny Squannit warned him not to touch her hair or face. When she fell asleep, the boy couldn't help himself. He crept up to the sleeping woman, pushed the hair from her face and saw revealed a single dark eye. That awful eye was wide open and glaring at him. That experience scared him straight, and it is believed the little boy grew up to be a great Wampanoag chief.

Other local Indian legends involve stories about giants and little people, witches and ghosts. The most famous Indian hero was the giant Mashop. He created islands and significant landmarks. It is said that he settled down on Martha's Vineyard and loved the cliffs of Gay Head (now Aquinnah). He cooked his beloved whale meat by tearing trees out of the ground by their roots, and this is why there are very few trees on Aquinnah. After Maushop warned the Indians that fair-skinned men were coming, he swam away and hasn't been seen since.

William S. Simmons, in his book *The Spirit of the New England Tribes*, wrote, "Now they say when the fog comes in, it is the smoke from Maushop's pipe

drifting in, or when whales appear in Menemsha Bay they say it is Maushop and his wife come to check on them."

Keepers of the old traditions are the sachems or chiefs of the tribes. During the 1970s, the Mashpee Wampanoag tribe was in a legal battle for its ancestral lands. The suit was ultimately denied. In 1975, Ellsworth Oakley became the tribe's supreme sachem and helped revive old traditions: the drums, the peace pipe, the chanting, the eagle dance. In a 1987 *Cape Cod Times* article, he was quoted as saying, "Ours is a rich tradition, one we should be proud of. I brought back the drum because it is the heartbeat of the Indian people. When the drum beats, it draws us closer to Mother Earth."

The Wampanoag traditions are also honored in the preparing of food. Fishing and hunting provide seafood and game, staples of native cookery. Many delicious dishes are taken to the annual powwow such as stuffed quahogs, corn or quahog fritters and the traditional clam bake, where food is cooked on hot rocks using rockweed, a form of seaweed. The Wampanoag live according to the rhythm of the seasons. When the Wampanoag greeted the Pilgrims in 1620, they taught the Pilgrims the many uses of corn and herbs.

In his *Cape Cod Wampanoag Cookbook*, Earl Mills Sr. wrote, "Living in harmony with the land leads to a peaceful and grateful heart. My people give thanks whenever a fish, animal or vegetable is taken from Mother Earth. We offer a prayer to the spirit of the gift and promise that we won't take more than we need and that we will not waste anything we take."

One of the great events of the year for the Wampanoag is the annual powwow, held on Fourth of July weekend and started in 1922. It is a homecoming celebration for tribe members and includes much dancing and drumming. The powwow begins with the Grand Entrance which is highlighted by dancing. The dances are both ceremonial and spiritual with dancers making their own costumes. Dances include fancy feather dancers, fancy shawl dancers, jingle dancers, as well as traditional dancers. One of the main attractions of the three-day event is "Fireball"—a medicine game played by Native men and boys where a ball made of old sheets and rags stuffed into a sphere of chicken wire is soaked in kerosene. This ritual resembles a soccer game. It is also part of a healing ceremony where players promise their courage for people who are seriously ill. The powwow was long held at the Douglas C. Pocknett Field on Route 130 and later moved to the Barnstable County Fairgrounds in Falmouth. It is a celebration as well as a sharing of the tribe's long history and culture.

The Old Indian Meetinghouse in Mashpee, Massachusetts, built in 1684. *Courtesy of the W.B. Nickerson Archives, Cape Cod Community College.*

During the last centuries, several buildings have held special significance to the Wampanoag. One is the Old Indian Meetinghouse in Mashpee, built in 1684. After the first Indian Church in Massachusetts was built in Bournedale in 1637, it was decided that the "praying Indians" of Mashpee needed their own church as well. Although originally built on Santuit Pond, the meetinghouse was moved in 1717 to its present location on Route 28 in Mashpee. In 1737, Indians petitioned the colony to repair the meetinghouse, but the petition was rejected. Fast-forward to 1986: the roof needed to be replaced. Finally, in 2009, the newly renovated church was reopened, having been shut in 2003 due to structural problems. To the Indians, the meetinghouse is sacred and stands guard over the Indian burial grounds on the hillside below.

A place of learning and community, Mashpee's one-room schoolhouse was built in 1831. It served as a school for fifteen families until 1901, when it was sold to the Young People's Baptist Society for twenty-two dollars. After

The one-room Mashpee schoolhouse, built in 1831. After renovations, it opened to visitors in 2009. *Courtesy of the* Cape Cod Times.

changing hands many times, it was returned to the town in 1975. After extensive renovations recently, the schoolhouse opened for visitors in May 2009. According to a *Cape Cod Times* article, the schoolhouse "is a time machine, complete with eight benches for 'students,' a pine replica teacher's desk, individual slates for each student, quills and inkwells and lanterns." This schoolhouse is a reminder of people of a bygone era investing in their children and passing down their traditions.

CAPE COD ODDITIES

How Cape Codders Speak

Did you know that Cape Codders who scraped a living on this isolated peninsula also had salty tongues? Their language was rich and exhibited many linguistic oddities. Such expressions as "old comers" for families who came over on the *Mayflower* were common as was the term "mooncussin," which stood for men who used lanterns to fool ships at sea to follow them. When the ships ran aground, the cursed "mooncussers" would plunder the waiting treasure. According to James Russell Lowell, New England poet in the 1800s, many Cornish words survived on Cape Cod. He wrote, "We note for instance 'housen' for house, 'banger' for very large, 'million' for melon, 'sheer' for share, 'sight' for a good many, 'bagnet' for bayonet, 'puss, nuss and wuss' for purse, nurse and worse, 'chaney' for china, 'chimbley' for chimney, and many kindred expressions, some of which still linger, all of which are in use in some parts of Cornwall."

In *Dialect Notes*, published in 1896 by the American Dialect Society, Cape Codders were shown to use the term "kilcow" meaning (he) "doesn't amount to much." Another common Cape Cod expression was "He doesn't do any more than he hasta." Even modern Cape Codders have their own expressions. "Down Cape" means the lower Cape, while the Atlantic side of the Cape is referred to as the "back side." In Martha's Vineyard, "Chappy" stands for Chappaquiddick, and "Down Island" refers to the towns of Tisbury, Oak Bluffs and Edgartown. "Over the bridge" means

any place off Cape, and of course, most locals will describe going over the bridges as "going off Cape."

Some terms were slightly derogatory, such as using "washashores" to describe people who live on Cape Cod but who weren't born there. Wellfleet was once known as "Dog Town," and Chatham was known as "Scrabbletown." An early name for Truro was "Dangerfield," possibly because the shoals there were so treacherous. "Thumpertown" was a place in Eastham named after religious revivalists or "thumpers." Some places have names that hark back to an older time. "Horse Foot Cove" in West Dennis was named after the horseshoe crab ("horsefoot" being an old term for horseshoe crab). Money Head on Hog Island in Orleans is where Captain Kidd may have stored his treasure. Mares Pond in Falmouth was named for a horse that drowned there many years ago. There are also many Cape Cod place names with Indian origins, such as Namequoit River, meaning "at the fishing place," and "Nauset," which means "at the place between."

CHIN BEARDS AND SEA CAPTAINS

In this age when anything goes, we forget that beards were not always in fashion. In fact, Abraham Lincoln was the first U.S. president to have a beard. When looking back at Cape Cod history, we note that sailors and sea captains often sported chin beards. Not to be confused with more contemporary soul patches or goatees, sailors preferred clean cheeks with trimmed hair along the chin but no moustache. It was a way for a sailor to keep his chin warm while looking trim and well groomed.

Historian Edward Stackpole, in a 1980 *Cape Cod Times* article, explained the allure of the chin beard. He said "it was a favorite of whaling captains, although many captains had smooth skin with no beard at all. But for those who wore chin beards, it may have been an easy way to have a beard without having too much."

Gregory Peck in his memorable role as Captain Ahab in the 1956 film version of *Moby Dick* wore a chin beard. A more recent convert to this fashion statement was former surgeon general C. Everett Koop. For a certain type of hardy person, it's a good choice.

Time Tales, or What Is Railway Time Anyway?

Before standardized time in this country came about with the arrival of trains, the passing of time was not an official science. According to webexhibits. org., standard time in time zones was instituted in the United States and Canada by the railroads on November 18, 1883. This was called railway time. Prior to that, the time of day was a local matter, and most cities and towns used some form of local solar time, maintained by a well-known clock (on a church steeple, for example, or in a jeweler's window).

This means that in earlier times people were possibly separated not only by distance but also by time. If a person needed to be at a wedding or funeral, how did he or she coordinate with others? Did someone simply say, "We'll gather midmorning," and wait for everyone to arrive? Of course, humans have told time by the sun for eons. Before the advent of electricity, farmers woke with the sun, worked by the sun and slept when the sun set.

One tragic accident in the 1800s woke people up to the need for standardized time. In August 1853 in New England, two trains on the same track and heading toward each other crashed because the train guards had different times set on their watches. Fourteen people were killed in this tragic and unnecessary accident. After this, train schedules were coordinated for safer travel. Standard railroad time was incorporated into federal law in 1918.

Several famous authors criticized railway time. Charles Dickens and Thomas Hardy wrote of human time conflicting with standardized time. English poet William Wordsworth penned: "Is then no nook of English ground secure from rash assault?" Now, of course, we have different time zones and the spring forward/fall back of daylight savings time. As Dr. Seuss once said, "How did it get so late so soon?"

The Drummer, an Early Salesman

In the nineteenth century, door-to-door salesmen were called "drummers." In a horse-drawn wagon, the drummer visited village homes and outlying farmhouses in order to sell trinkets and necessities. He was a seller of small goods. This life on the road could be a lonely one, and drummers would often find pubs or publick houses hospitable places to spend the long nights.

According to Walter A. Friedman, in his book *Birth of a Salesman: The Transformation of Selling in America*, wholesale drummers "traveled on trains

and wagons, hauling trunks filled with merchandise samples or carrying thick catalogs, and were usually paid a mixture of salary and commission." So the drummer or canvasser was an early form of the modern-day sales rep.

The term "drummer" carries several different meanings. First, "drummers" carried trunks or "drums" full of merchandise. Second, the term might have come from the salesmen trying to "drum up" business or being persistent in their sales pitches (i.e., "beating a drum"). This idea of drumming up business was also similar to the musician drummers who preceded traveling shows.

According to the book *The Names of Cape Cod*, Wellfleet's Drummer Cove has a different origin. The drummer is a local name for the squeteague or weakfish. Of course, the common definition is "one that plays the drum." Whatever its origin, the traveling drummers faded out with the advent of the automobile.

ILL-FATED SEA VOYAGES

There have been many stories of old shipwrecks and missing seamen. Due to Cape Cod's position as an arm sticking out into the Atlantic Ocean, many perished along its coast. Here are some tales of lost ships and heroic rescues.

A little-known story is that of the 1877 sea voyage of Captain Thomas Crapo and his wife, Johanna. The young couple (ages thirty-four and twenty-two) set out from New Bedford on May 28, 1877, in a twenty-foot-long, two-masted cedar dory bound for England. The pair had only biscuits, canned meat and water on board. Originally, Captain Crapo had planned a solo journey, but his wife insisted that she accompany him. With lots of advance publicity, the couple's exploits were newspaper fodder countrywide.

Unfortunately, as soon as their journey started, the dory took on water and the couple had to pull into Chatham to repair their boat. After staying with Captain Darius Hammond for four days, they were ready to embark again. The long-anticipated journey quickly turned into a nightmare. Johanna was seasick, their bed was too short for them to stretch out completely and then it started raining. Sleeping became even more uncomfortable. To add to their misery, Captain Crapo had to take watch duties for twenty hours a day to look out for bigger ships with his wife keeping watch the other four hours. Also, they had to contend with playful whales that often ventured close to their boat. As their trip progressed, they hailed passing ships to give them news to send back to the newspapers back home.

Finally, fifty days after leaving Chatham, they arrived at Penzance, England, on July 21 at 11:00 p.m. Because it was late at night, there was no one to greet them, but the next day, they received a hero's welcome. They capitalized on their growing fame by turning their adventure into a sideshow exhibit. For four months, they traveled around England telling their story. Then, in January 1887, they returned to New York aboard a steamer. They performed at Madison Square Garden and later toured with a London circus. When they grew tired of traveling, they returned to New Bedford with their profits. Although Johanna declared that she was done with sea life, her husband had enough money to buy his own schooner and made a living delivering cargo, including making deliveries to Provincetown.

In later years, Captain Crapo captained several ships, returning only when one sank off Cape Hatteras in 1885 with half of its crew missing. With his funds dwindling, he decided to write a book about his adventures. In 1883, he published his autobiography entitled *Strange but True*. Then, in 1899, at the age of fifty-seven, Captain Crapo drowned when his skiff became entangled in fishing nets off Sakonnet Point, Rhode Island. It appeared that he had been trying to remove his boots so he could swim more easily but was too entangled to free himself.

Outliving her husband by ten years, Johanna spent her remaining years in a New Bedford rooming house. According to a 1969 article published in the *Cape Cod Standard Times*, Captain Crapo's book "details a life of adventures, from the time he ran away to enlist as a cabin boy on a whaling ship at the age of 14, through his Civil War experiences in both the Navy and Army, his life among natives in the South Sea Islands when he deserted ship, knifings, near drownings, and enough to make an old-time serial look tame." He lived an exciting, adventurous life and was lucky to find the perfect woman to share his adventures with him.

Chatham Light Monument Recalls Tragedy of 1902

Cape Codders have always lived in the shadow of maritime disaster. One particular tragedy took place on March 17, 1902, when two barges were stranded off Chatham, the *Fitzpatrick* and the *Wadena*. A bad storm blew up as members of the *Wadena* were busy trying to salvage their belongings. Their distress signal was spotted by members of the old Monomoy Life

Saving station, and a boat was sent out. Eight members of the lifesaving station set out that day to rescue crew members of the *Wadena*.

The lifesavers rescued all hands on deck, but as they were turning the boat for their return trip, a huge wave caught them broadside. The lifeboat capsized, and only one man survived. Eight lifesavers and four *Wadena* crew, including the owner, William H. Mack of Cleveland, died. The lone survivor was Captain Seth Ellis. On board the *Fitzpatrick* at this time was Captain Elmer Mayo. He set out alone to rescue anyone who could be saved and brought Ellis back safely. Later, many felt that the lives lost were needless since the *Wadena* was untouched by the storm and the crew would probably have been safe if they had weathered the storm on board the stranded vessel. The rescue was attempted since no distress signal could go unanswered.

According to the Chatham Light station website, "The memorial monument near the foundation of the old North Light Tower commemorates the heroic efforts of Captain Marshall N. Eldredge and six Lifesavers from the Monomoy Life Saving Station who drowned attempting to rescue survivors of the coal barge, *Wadena* on March 17, 1902. The barge was grounded on Shovelful Shoal." Around the base of the memorial are listed the names of all who lost their lives. The monument was originally called the Mack Memorial since it was donated by the mother and sister of the owner. They wanted to have the memorial erected within sight of where the tragedy took place. It is interesting to note that the two survivors of this tragedy—Captains Mayo and Ellis—died within two months of each other in 1935.

A DARING RESCUE

Over sixty years ago, thirty-two seamen aboard a sinking tanker were rescued during a ferocious storm by four Coast Guardsmen. The tanker had been crippled by winter weather five miles off Chatham. An old *Cape Cod Standard Times* newspaper clipping from February 18, 1953, tells of the near peril faced by the rescued men. "It happened a year ago today. The tanker *Pendleton* broke in two in storm-roiled waters off Chatham. The bow is shown shortly after the split. Nine lives were lost, but a Coast Guard rescue operation described as 'unique in Coast Guard history' saved the lives of thirty-two of the crew." All told, Coast Guardsmen saved the lives of fifty-seven men in direct operations from the *Pendleton* and from the *Fort Mercer*, another tanker that by rare coincidence split in two the same day. A dramatic

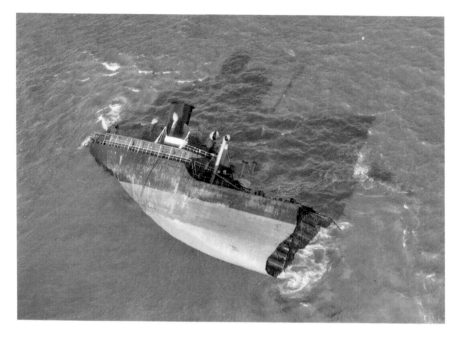

The sinking of the *Pendleton*, circa 1957. *Courtesy of the* Cape Cod Times.

photo accompanying the caption shows the dark bow of the *Pendleton* in the stormy weather. There was one casualty during the rescue. Crewman George "Tiny" Myers, three hundred pounds, fell into the sea from the ladder after helping others to safety. Bernard Webber, the skipper, jammed the motorboat into reverse in a desperate attempt to rescue Myers, but he was trapped between the tanker's hull and the lifeboat and perished.

The thirty-six-foot motor lifeboat was sent from the Chatham Lifeboat Station. When the men were rescued, several came aboard the rescue boat seconds before the hull of the tanker overturned and sank. Once ashore, the wet and weary survivors were taken to the lifeboat station for hot coffee and dry clothing. The four crew members who took part in the rescue were Seaman Richard P. Livesey, Boatswains Mate First Class Bernard C. Webber, Seaman Ervin E. Maske and Engineman Second Class Andrew J. Fitzgerald. In a *Cape Cod Standard Times* photo captioned "Saved Tanker Survivors," the four look tired but happy. They stand together, arms around their mates, and stare with big smiles into the camera. Award of Merit medals were presented to ten Chatham Coast Guardsmen for their part in the rescue, including the four pictured in the *Times*. They would also garner Lifesaving Medals in Washington that May.

On February 25, 1952, the body of a crewman was discovered in the hulk (an unseaworthy hull still in limited floating service). Herman Gordon Gatlin, twenty-six years old, was found wrapped in a sawdust bag. He had apparently died due to shock and exposure. Eight others were trapped in the bow of the *Pendleton*, and their bodies were never recovered.

Later, in April 1952, efforts were begun to salvage the bow section of the Pendleton. On April 11, after being refloated, the tanker was pushed about 200 feet by wind and a swift tide, then struck an underwater ledge. Later, the bow and stern sections were sold to different buyers.

Fifteen years after the incident, the *Cape Cod Standard Times* ran an editorial that read, in part, "Despite tragedy stalking the off-shore waters that afternoon, it was a shining hour in the history of the U.S. Coast Guard. Herculean efforts by Coast Guard crews from the Chatham station eventually brought 36 men from the *Pendleton* ashore safely…Modern rescue methods and communications have cut down the dangers, but the raging majesty of a stormy sea can still take a toll."

The boat was decommissioned in 1968 and spent twelve years behind a maintenance building at the Cape Cod National Seashore headquarters in South Wellfleet. In 1981, the society reached an agreement with the National Park Service to restore the craft. Finally, in 1982, Governor Edward J. King signed into law a bill authorizing the Orleans Historical Society to use "CG36500" as the registration number for the Coast Guard boat used in the *Pendleton* rescue.

Sixty years later, the ocean still takes it toll. More recently, lives lost in the Perfect Storm of 1991 when a fishing boat out of Gloucester, Massachusetts, went missing along with its crew off the Outer Banks show that those at sea can't second guess nature. The actions of human beings, however, make a difference. The *Pendleton* rescue, both heroic and legendary, will never be forgotten and is considered one of the most difficult rescue missions of all times.

THE *ELDIA*: A MALTESE FREIGHTER RUNS AGROUND

On March 29, 1984, a 486-foot Maltese freighter was stranded off Nauset Beach in East Orleans. The ship remained stranded for forty-nine days, drawing tourists and gawkers to visit its resting place. It was blown off course during violent winds and rain. The storm also left 100,000 without power.

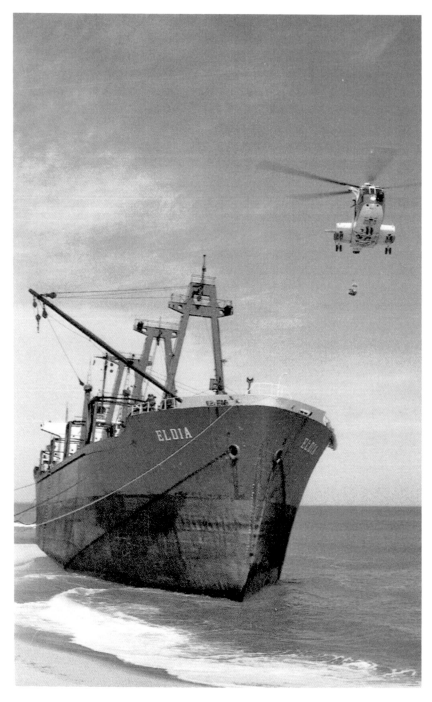

A postcard of the *Eldia*, a steel freighter that was blown ashore in East Orleans in 1984. *From the postcard collection of Wendell E. Smith.*

The *Eldia* had left from St. John's, New Brunswick, the previous Tuesday after dropping off a load of South American sugar and was bound for Norfolk, Virginia. When the weather worsened, heavy seas were pounding its broadside and driving it relentlessly toward Nauset Beach.

The captain, Ernesto F. Garces, dropped two anchors. Like his crew, the captain hailed from the Philippines although the ship was owned by a Greek company. The waters off the Outer Cape are known for treacherous shoals and ever-changing sandbars. Mariners have had trouble navigating these seas for centuries. The Coast Guard received word at 3:56 p.m. that a ship was just off shore and it looked like it was going to come aground.

By the time rescuers arrived, the *Eldia* was almost onshore. It was parallel to the beach, its bow heading north. The Orleans fire chief, Raphael Merrill, sounded the alarm. Fire trucks and ambulances raced to the scene. Fire departments from Eastham, Chatham, Brewster, Harwich and Wellfleet were called. The Coast Guard responded as well. In all, three dozen vehicles came to the rescue.

The Coast Guard sent out an HH-3 twin-engine helicopter. It was the largest helicopter used by the Coast Guard at the time and was designed for search-and-rescue missions. At 5:07 p.m., with the tide coming in and darkness advancing, the helicopter approached the *Eldia*. A rope was lowered from the helicopter with a basket at its end that could fit two people. So, two at a time, the crew was lifted off the ship to a parking lot located about half a mile away. After thirteen rescue runs, the helicopter saved twenty-three men.

Eventually, the ship grounded on the beach. Come morning, it was surrounded by sand. The first order of business was to get 100,000 gallons of fuel off the ship. When the weather improved, people began to visit the beached ship. By the time it was salvaged forty-nine days later, it was estimated that 150,000 people made the trek to see and snap pictures of the *Eldia*. The town of Orleans collected over $80,000 by charging $2 per carload for parking. Town workers used snow fences to close access to the dunes. Business was brisk in area shops with store owners selling *Eldia* mugs, beverage glasses, buttons, postcards and T-shirts.

The ship was finally drawn off the beach by salvors by use of anchors and a steam barge on May 17, 1984. It was pulled around Provincetown through Cape Cod Bay and the Cape Cod Canal to a Rhode Island shipyard. It was later taken to a scrap yard in Staten Island and cut up in the late 1980s. The grounding of the *Eldia* was a shipwreck to be remembered with no lives lost and the ship salvaged intact.

A CAPE COD LOVE STORY

Cape Cod has long been home to artists, free thinkers and nature lovers. It is also, like Paris, a romantic destination with its dreamy inlets, long sandy beaches and memorable sunsets. Here is one tale of love that has stood the test of time.

There was once a handsome, dashing sea captain who had two loves: sailing the high seas and seeking the hand of his soon-to-be-wife. Born in 1811, Ebenezer Harding Linnell grew up on Barley Neck Road in Orleans. He married the love of his life, Rebecca Crosby, in 1835. They were a striking pair. He had dark hair, bold eyes and full lips, while she had shining blond hair and dainty features. Ebenezer was often at sea, while his wife stayed home with their three girls: Helen, Florentina and Abby. According to a *Cape Cod Times* article, it was said that Captain Linnell was married to the sea and having an affair with his wife.

Captain Ebenezer was making a name for himself on his seagoing travels. In 1855, he captained a clipper ship called the *Eagle Wing* that sailed from London to Hong Kong in eighty-three and a half days. It was a record that brought him fame among the world's clipper masters. He also helped develop a top-rig sail that became popular and was later patented.

His feats and exploits made him a wealthy man by age forty. Around 1860, when the couple outgrew their first home on what is now Skaket Beach Road in Orleans, Ebenezer commissioned his father-in-law to build a grand house to be built modeled on his French shipping agent's Neo-classic villa in

Marseilles. The captain called his fine house Namskaket, and it would later become the Captain Linnell House Restaurant.

After he went back to sea in 1862, Ebenezer's luck changed. When his ship, the *Flying Mist*, was anchored off New Zealand, it drifted off its moorings and was destroyed on nearby rocks. He was able to save his cargo, but his luggage and money were stolen. He was not as wealthy after this bit of bad fortune. Still, he had his wife and three daughters waiting for him at home. He might have been content to finally stay on dry land, but he decided to go out on one last voyage.

On January 29, 1864, Ebenezer's ship the *Eagle Wing* was struck by a severe storm. The fifty-three-year-old captain was crushed against the ship's wheel; his left lung was punctured and his ribs broken. After an agonizing four days, he died. In time-honored tradition, he was buried at sea, and the ship returned without him. That same ship, on its next voyage, was lost along with all its crew. Historian Henry C. Kittredge, in his book *Shipmasters of Cape Cod*, wrote that "for native ability, energy and shrewdness, few American shipmasters were his equal."

Rebecca must have been distraught on hearing the news of her beloved husband's death. She died at age eighty-one in 1895. She is rumored to sit in one of two cupolas on the top of her magnificent house, perhaps awaiting Ebenezer's return. The abandoned villa was later bought and restored. A financier bought the place in the early 1900s, and by 1946, it had become a café. It seems fitting that present-day couples can rekindle their own romances by dining at the Captain Linnell Restaurant where once a clipper ship captain and his bride found happiness.

LOCAL LEGENDS

THE STORY OF PRINCESS SCARGO

The history of Dennis has its roots in the early days of Cape Cod. Many of its landmarks are steeped in Indian lore, including Scargo Lake (just off Route 6A), one of the deepest bodies of water on Cape Cod. The name "Scargo" is an Indian name possibly meaning skunk; therefore, Scargo Lake may have appeared to have the shape of a skunk.

According to legend, the tale of Princess Scargo is an enchanting one. It began when a tribesman and potential suitor brought her a hollow pumpkin filled with water and fishes. She placed her gift in a small pool, but after it dried up, the princess was frantic. Her father, sachem of the tribe, ordered a basin dug. The precious fish were saved by the autumn showers that filled the basin and formed Scargo Lake.

One version of this legend says that the princess drowned from the onslaught of rain, but the lake has been well stocked with fish ever since. Her death was viewed as a sacrifice since she saved her village by being the agent for much-needed rain. The earth thrown out from the making of the lake formed Scargo Hill on which stands one of the highest structures on Cape Cod: Scargo Tower.

Another version of this Indian legend speaks of legendary giant Maushop. He watched over area Native Americans. After uniting various Indian groups, he had a visit from a tribe dwelling in Nobscusset. They wanted assurance that he was looking out for their welfare. After giving the matter

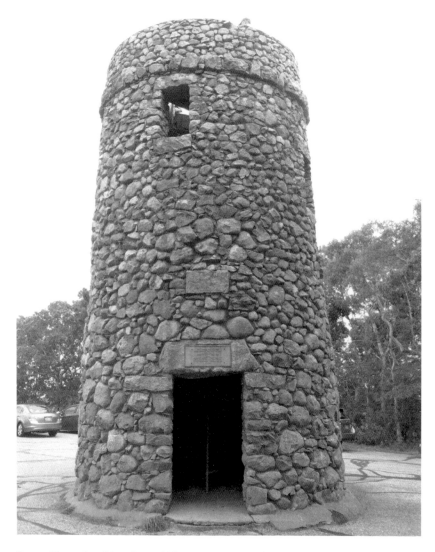

Scargo Tower is a thirty-foot cobblestone tower atop Scargo Hill. *Photo courtesy of Gregory R. Johnson.*

some thought, he dug a pond for his people. The soil scooped from his efforts became Scargo Hill, and the water-filled hole became Scargo Lake.

According to the Dennis Historical Society, Scargo Tower began as a tourist observatory in 1874. When the wood structure burned down in

1900, the thirty-foot tower was rebuilt in cobblestone and opened in 1901. It commemorated Thomas Tobey, who settled in Dennis in 1678. The Tobey family donated the tower to the town in 1929, and it still stands to this day.

Cape Cod's Target Ship

In the 1960s, residents of the Lower Cape were often awakened by the boom of planes bombing the target ship resting in Cape Cod Bay. The official name for the target ship was the *James Longstreet*. After being grounded in 1944, it was moved to the Wellfleet-Eastham area of the bay for the purpose of target use after World War II. The hull of the ship, if seen up close, was pockmarked with holes.

In 1970, there were a series of articles and editorials of the threat posed by the continued bombing of the ship following the report of a seventeen-year-old boy in Wellfleet losing a finger after a live bomb, taken from the target ship, exploded. It was the only incident of injury since records began being kept in 1949. Ultimately, the navy erected prominent signs to warn people of the dangers there. The bombing of the ship ended in the early 1970s when U.S. state representative Gerry Studds succeeded in persuading the navy to stop the exercises.

A different scenario awaited two Wellfleet fishermen who found safe harbor near the target ship. They were reported missing after they left for a trip to Provincetown. Many area residents spent the night in early April 1971 searching for the missing pair. The forty-eight-foot vessel had run into bad weather and spent the night in the lee of the target ship. Since the weather had knocked out the radio antenna, the two were unable to alert anyone to their whereabouts. In the morning, they were able to travel home to be met by their anxious family and friends.

During the 1980s, there were rumors that the ship would be sold to salvagers. A campaign to save the ship culminated with T-shirts that read "Save the Longstreet." The unthinkable happened in 1997 when an April Fool's blizzard covered the last traces of the old target ship. Since that time, the ship has vanished from sight as it lies in about twenty-two feet of water at the bottom of Cape Cod Bay.

THOREAU STAYED AT THE OLD HIGGINS TAVERN

Today we take for granted the fact that Cape Cod is a popular tourist destination, but 150 years ago it wasn't well known until Henry David Thoreau decided to trek across Cape Cod in 1849. He fell in love with what he saw. It was his plan to study the Cape's people, flora and fauna. Since the only way to travel aground the Cape in the mid-1800s was by horse and buggy, Thoreau traveled here by stagecoach and put up at the Higgins Tavern in Orleans.

In his book *Cape Cod*, published in 1865, in the chapter titled "Stage Coach Views," Thoreau wrote, "At length, we stopped for the night at Higgin's Tavern in Orleans, very much as if we were on a sand bar in the ocean, and not knowing whether we should see land or water ahead when the mist cleared away." When Thoreau and his friend Ellery Channing left the tavern on October 11, 1849, they hiked around Nauset Harbor and north across Jeremiah's Gutter, the old canal that once bisected the Cape. To this day, people recall his description of Cape Cod as "the bare and bended arm of Massachusetts."

And what happened to the Higgins Tavern? According to a 1973 *Cape Cod Standard Times* news article, "The house that was once the old Higgins Tavern, a famous stagecoach stop became a nightclub and burned down in the late thirties." In 1933, part of the Church of the Holy Spirit in Orleans was constructed from a section of the Higgins Tavern. Now the Olde Tavern Motel & Inn on Route 6A in Orleans is on the site of the Higgins Tavern. With so many reminders of Thoreau's visit, it is possible to imagine that the spirit of Thoreau still wanders the great beach to discover its beauty and solitude.

A LEGENDARY BELL

A story of triumph and redemption started with a tragedy. In 1702–03, a ship under the command of Captain Peter Adolph of New York sank in Cape Cod Bay. It had left New York and was headed for Boston. The bodies of the captain and his crew washed up on the shores of Sandwich. Local residents collected the bodies at the First Parish Church for a burial service. From letters found on one of the bodies, Captain Adolph was identified, and notification of his death was sent to his widow by the Reverend Roland Cotton. The captain was buried in the Old Town Cemetery in Sandwich.

Captain Adolph's widow was so grateful for services rendered to her husband that, in 1703, she presented the First Parish Church with a brass bell, cast in 1675. A small bell, it measured eighteen inches in height and diameter and thirty-two inches in circumference. It is possible that the captain's wife hoped the bell's tolling would reach the graveyard where her husband was buried.

The bell hung in the church for sixty years, but by 1763 the town had grown and when the church was enlarged, a bigger bell was needed. At the next town meeting, Sandwich residents wanted to see the Captain Adolph Bell given to the justice of the Sessions, as the courts were then known as, to be hung in the Barnstable County Clerk of Courts offices, the Registry House.

In an interesting side note, Titus Winchester, the last slave in Sandwich, died in 1808. He had refused to leave his master, a former minister, until after his death. After Titus gained his freedom, he worked as a ship's steward and, after putting aside a considerable sum, returned to Sandwich. In his will, he left funds for a steeple clock for the First Parish Church. In use for over sixty years, the clock was referred to as "Old Titus."

Fire destroyed the courthouse building on August 22, 1826, but the belfry, where the bell hung, fell away from the flames and the bell was recovered only slightly damaged. In another unfortunate incident, on Fourth of July 1872, village boys borrowed a blacksmith's hammer and pounded the bell until it cracked. When the granite courthouse in Barnstable Village was completed in 1933, the bell was remounted in the cupola where it rang morning and night. Two years later, the bell was retired and sat in a dusty corner of the law library in the Clerk of Courts office.

In 1963, several Sandwich residents decided to recover the historic bell from Barnstable. It was returned to Sandwich that year. Nowadays, the bell is on display in the entrance of the First Church of Christ in Sandwich. Around the top of the bell is a Latin inscription taken from the book of Romans: "If God Be For Us, Who Can Be Against Us?"

CAPTAIN WESTON JENKINS: UNSUNG HERO OF THE WAR OF 1812

Along the Falmouth green are many old, historical homes, including the birthplace of Katherine Lee Bates. There is also a stately house, a Federal-style colonial with twin chimneys built in 1822, that was home to Captain

Weston Jenkins. It now goes by the name of the John Jenkins house (named after Weston Jenkin's son). Captain Weston Jenkins played a crucial part in defending the town against the British during the War of 1812. In fact, in 1807, he formed the Falmouth Artillery Company.

During the War of 1812, the HMS *Nimrod*, a British man-of-war, patrolled New England waters in an effort to limit American shipping. In 1814, the *Nimrod* demanded the return of several small cannons. With some bravado, Jenkins is reported to have said, "If you want them, come and get them." The *Nimrod* fired cannons at Falmouth and damaged some buildings. In the end, the *Nimrod*'s attack failed, with the ship later running aground in Buzzards Bay.

Captain Jenkins was married to Elizabeth Robinson (known as Betty), and together they raised nine children. During the siege on Falmouth, the town was given a day to prepare before the British began their attack. All the women were removed except for Betty Jenkins, who cooked for the three hundred men in the trenches.

For many years, customers could observe a large hole in the men's room of the now defunct Nimrod Restaurant on Dillingham Avenue, allegedly made by a cannonball shot during this raid. As for Weston, he died on February 13, 1834. He might be remembered in a phrase used in the town's bicentennial in 1976: "Where once the militia trained, peace now reigns."

Hannah Doane, Wellfleet Firebrand

Before Wellfleet split away from Eastham, it was known as Billingsgate, after the famous fish market in London. When Wellfleet was incorporated as its own town in 1763, only the island off Wellfleet remained known as "Billingsgate." It took thirty years of petitioning by local townspeople to have their own town. An influential spokesperson for this movement was Hannah Doane.

Born in 1666, she later married Squire John Doane III in 1696. He was a descendant of one of the seven original settlers of Eastham. The couple settled in Billingsgate, where Hannah became one of the most outspoken proponents of separating from Eastham. At that time, Billingsgate had its own meetinghouse, minister and schoolhouse; however, the town of Eastham was unwilling to lose out on prospective taxes and the rich fishing grounds off of Billingsgate.

In 1718, the town of Eastham brought in a new minister, Reverend Samuel Osborn. Having their bid for independence turned down at a town meeting angered the citizens of Billingsgate, so they decided to discredit the newly appointed minister. It was rumored that he had a child out of wedlock, and Hannah even sailed to Boston to look up material she might use against him. She was one of seventeen people who signed a petition against Osborn's ordination. Most of the signers were later persuaded to retract their words, but Hannah and three other women refused.

In 1719, the four women were admonished for a case of "disorderly walking." It was really their stand against the church that led to their troubles. The deacons and the women's husbands pressured the four, and three of the women backed down but not Hannah Doane. She stood by her word. She was later excommunicated from the church and lived to be sixty-five years old. In a time when women were supposed to remain quiet and obey their husbands, Hannah was truly a woman born before her time.

The Man with the Branded Hand

Captain Jonathan Walker, born in Harwich on March 22, 1799, would become known as the first "slave liberator" of Cape Cod. After going to sea at the age of seventeen, he later became captain of a fishing vessel and then a railroad contractor.

In 1844, Walker was jailed in Pensacola, Florida, and had his right hand branded with the letters "SS," which was short for "slave stealer." With his naval experience, he had planned to take seven slaves to the West Indies but, after falling ill, was rescued by a passing ship and escorted to Key West. He was taken in chains to Pensacola, where he was charged and convicted of slave theft. Harwich residents raised money to pay his fine of $600 (a huge sum for those days). He later wrote about the degrading conditions of the prison and compared it to the brutal treatment of slaves.

In later years, it is thought that Walker, along with his wife, Jane, were conductors in the Underground Railroad, helping slaves escape to free states. He became friendly with William Lloyd Garrison, the prominent American abolitionist, and spent four years lecturing throughout the country for the antislavery cause. With his family, he moved to Michigan in 1850 and died there on May 1, 1878. To many, he was a national hero

for his fervent antislavery stance. He was also the subject of John Greenleaf Whittier's poem "The Man with the Branded Hand." There is a plaque commemorating him on the lawn of the Harwich Historical Society.

CAPE COD'S OWN BIRD CARVER

Bird carver A. (Anthony) Elmer Crowell, one of Cape Cod's most famous figures, led an interesting life. A life-long Cape Codder, he was born at the family homestead in East Harwich (Route 139) in 1862. From an early age, he was interested in nature and wildlife. He was given his first twelve-gauge shotgun by his father at age twelve. It was his love of hunting that eventually led to his affinity for bird carving. At age fourteen, his dad bought him a large tract of land on the south shore of Pleasant Lake in East Harwich that had an ideal beach for his bird decoys. In 1900, Crowell was hired by Dr. John C. Phillips to manage his hunting camp at Wenham Lake, north of Boston. This was a formative time in his young career. There he stayed for ten years as a waterfowling guide. It was at this time that he started selling his many decoys and decorative carvings. His going rate was twenty-four dollars a dozen or two dollars a piece.

In 1912, he started carving full-time, working out of a small shop in his home in East Harwich. Unlike other decoy carvers of that time, Crowell signed his pieces. This practice helped to carry his name beyond Cape Cod and build his fame as an outstanding craftsman. He was, and still is, known for having paid meticulous attention to detail both in the carving of bills and feathers but also in the painting of the feathers of his decoys.

He was a prolific bird carver for his entire working life, often putting in six-day workweeks. Rheumatism finally forced his retirement in 1943. His son, Cleon, born in 1891, continued the work his father started. Elmer Crowell died on January 1, 1952. He left a legacy that is still treasured by art collectors and museums. In September 2007, two of Crowell's decoys, a pin-tail drake and a Canada goose, sold for a record $1.13 million. On a lighter note, Elmer Crowell was the original "Queer Judson" character made famous by author Joseph C. Lincoln.

BELIEVE IT OR NOT

In the annals of Cape Cod history, some stories are so unusual that it's hard to tell whether they are fact or fiction. Here are some intriguing tales to excite surprise and wonder in the reader.

TALKS OF SECESSION HAVE A LONG HISTORY

Believe it or not, both Cape Cod and the Islands have, at one time and another, considered secession. For example, in 1977, both Nantucket and Martha's Vineyard considered seceding from Massachusetts. This came about when state lawmakers suggested combining the islands with the Lower Cape under a single representative in the Massachusetts house.

In 1993, the quiet village of Cotuit had secession from the town of Barnstable on its mind. The civic association wrote up a report showing what secession might mean for the village. The 1993 report said, in part, "From the dangerous traffic situations…to the unkempt appearances of our beaches, mooring and recreational areas…[various conditions] have left a large group of residents calling for secession from the town." Many town residents had complained that Cotuit didn't receive enough police, public works or other town services. In February 2009, some Cotuit townspeople again mentioned secession in light of the Barnstable School Committee's decision to close Marstons Mills–Cotuit Elementary School.

Ideas about secession are not new to this area. In fact, the concept is mentioned in *The Seven Villages of Barnstable*. In one section, the book states, "There were many attempts to divide the towns…In the period 1837 to 1852, twelve such attempts were made." In more recent times, members of the Barnstable County Selectmen's Association called for a study to create an "independent state of Cape Cod." Many other places around the country have had secession attempts, including California, Colorado, Connecticut, Maine and Maryland to name a few. Maine successfully seceded from Massachusetts to become a new state in 1820.

So, perhaps with talk about bridges to the islands and a (fantasy) subway system linking various parts of Cape Cod, the idea of secession may once again come to the forefront.

THE CIVIL WAR OF WELLFLEET

Although civil war ripped through the United States and through families as well during the 1860s, another more lighthearted civil war occurred in later years on Cape soil. At the turn of the century (1900s), there was a feud between Wellfleet and South Wellfleet boys who were fighting over ownership of a Civil War cannon. It was originally one of two cannons, but

Uncle Tim's Bridge in Wellfleet, Massachusetts, on a foggy day. *Courtesy of the* Cape Cod Times.

the first blew up during an Independence Day celebration. It then became tradition to steal the remaining cannon.

The Wellfleet boys thought Cannon Hill was the appropriate spot for their relic, so they marched across Uncle Tim's Bridge to move it. The South Wellfleet boys vowed to reclaim their treasure. These soldiers wore no uniforms, only dungarees.

According to a 1943 *Cape Cod Standard Times* article, "Wellfleet [boys] attempted to outwit the rightful owners by plotting to let the South Wellfleet boys load the cannon but then maneuvering to have it roll back of its own weight by cutting the traces." The South Wellfleetians wouldn't be fooled. They came with chain traces, and the cannon was rolled back across the bridge to its proper resting place. The cannon was later buried to put an end to the recurring larceny.

Myria Hicks, the daughter of Clarence Hicks, the last surviving member of a group of men who buried the cannon, decided to look for it after the death of her father. Before he died in 1949, he told the secret of its location to his two daughters. It was dug up in 1974 and later encased in cement and placed on the town hall lawn. Once sealed, it could never be fired again. Thus ended the saga of the mystery cannon.

A CAPE COD WITCH

What would Cape Cod history be without a bonafide resident witch? Two centuries ago, Liza Tower Hill haunted the byways of Barnstable along with her ghostly black cat. She was born Elizabeth Lewis in either 1711 or 1712 and married William Blatchford, a Londoner. Her witch name, Tower Hill, came from a section of London near the famed Tower of London.

When her husband died in 1755, she was left a small estate and the care of seven young children. She and her husband had made their home deep in the woods near Half Way Pond and only came into town for Sunday services. Sometimes townsfolk, having strayed off the beaten path, would see her dancing on the pond. Her nightly wanderings made her neighbors uneasy, although many were bewitched by her attractive good looks. According to a news article from the *Cape Cod Standard Times* of May 15, 1946, "A Mr. Wood of West Barnstable charged Liza with putting a bridle and saddle on him and riding him many times to Plum Pudding Pond in Plymouth where the witches reputedly had nightly orgies."

She was also reported to have a fierce temper and was not someone to cross. When Liza's daughter, Lydia, went to work for James Allyn Jr. of Barnstable as a servant, within a year, Lydia returned, saying the Allyns had mistreated her. The Allyns had to contend with Liza's anger and her big, black yellow-eyed cat. When the cat showed up at the Allyns' doorstep, minor disasters happened: "Milk soured, illness descended, doors squeaked open and furniture flipped, always by unseen hands and always in accompaniment with the apparition of the huge black cat."

In later life, Liza felt mildly persecuted and seemed to want to be an honest, pious and industrious person. According to legend, she met her demise in a very unusual way. In 1790, her black cat chased a frightened sea captain, Benjamin Goodspeed, around Cape Cod Bay. He apparently loaded his gun with wadded Bible pages and fired into the terrible eyes of the cat. This apparently killed the cat when regular gunshot did not. Liza, reported to be at her spinning wheel, died at the same moment as her cat did. Since a cat is regarded as a witch's familiar, bonded throughout life, Liza must have had her life force snuffed out at the same time as her companion. It is even said that in her lifetime she could transform into a black cat.

Whether reports of witchcraft are real or figments of overactive imaginations on the part of hysterical bystanders, the stories make for magical retelling over campfires or in the depths of winter while staring into the dancing flames of one's living room hearth.

NEW ENGLAND'S DARK DAY: MAY 19, 1780

Imagine waking to a new day. People rise to go about their daily rounds. Then, around 10:30 a.m., the sky darkens, and by 2:00 p.m., in Barnstable, it is so dark that candles need to be lighted. This scenario was real on May 19, 1780.

For people living shortly after the Revolutionary War, this was a terrifying event. Birds sang their evening songs at noon, while chickens came home to roost. Frogs began their nighttime croaking. Some people found they couldn't even read when holding a book a few inches in front of them. The darkness extended as far north as Portland, Maine, and as far south as New Jersey. In fact, in the days prior to the daytime blackness, the sun had appeared red and the sky yellow. In New England, there were some accounts of an ashy smell in the air.

The night following this dark day held no moon and no stars. It was the darkest night many people had ever witnessed. What could have caused this aberration of nature? Religious zealots thought this was the judgment day. Other people were simply bewildered by the turn of events. Some villages marked the first anniversary of the dark day with prayer and fasting.

American poet John Whittier wrote a poem, "Abraham Davenport," that contains these lines: "Men prayed, and women wept; all ears grew sharp/ To hear the doom-blast of the trumpet shatter/The black sky." Davenport, a member of the Connecticut legislature, responded to his colleagues' fears with courage and common sense in the face of what appeared to be a supernatural event.

Recent scientific evidence points to massive wildfires that drifted down from Algonquin Provincial Park in eastern Ontario at the time of the great smoke and darkness. Whatever caused New England's Dark Day, the historic accounts make fascinating reading.

GOBLINS AND GHOSTS

In the annals of spooky Cape Cod, many names stand out: Granny Squannit, the Pamet puma, Maria Hallett and "Black Sam" Bellamy (famous pirate of *Whydah* fame). Ghosts have been seen in old houses and graveyards; even sea monsters have surfaced from time to time. But perhaps the most compelling strange phenomenon was the "Black Flash," a horrifying specter that terrified children and grown-ups in Provincetown in the early part of the twentieth century.

According to Peter Muise, blogger on New England folklore, the legend went like this: "Back in October 1938, Provincetown was haunted by a phantom that locals dubbed the Black Flash. Unlike your average ethereal wispy ghost, the Black Flash was nearly eight feet tall, unnaturally strong, and wore all black clothing, including a flapping bat-like cape. To top it off, he had glowing eyes and possibly breathed fire."

Eyewitnesses were alleged to have said that the Black Flash was tall, black and sometimes growled. It was also said he had superhuman strength and agility. This so-called Devil of the Dunes initially scared children, but then an adult—Marie Costa—came forward with her tale of an encounter with the terrifying apparition. The police went looking but couldn't find a trace of what sounds eerily like the bogeyman. In the days following, more people saw the phantom and heard his maniacal laugh. Accounts like this continued for several years. It was reported that a group of children overcame the Black Flash in 1945, when one of the group, a brave girl, threw boiling water on the overgrown goblin.

An old-fashioned depiction of the main thoroughfare in Provincetown. *From the postcard collection of Wendell E. Smith.*

When I was visiting Alan Moffett (son of the late Provincetown artists Ross Moffett and Dorothy Lake Gregory) in his adopted city of Pasadena, Texas, he remembered the legend of the Black Flash with a laugh. "Why, I haven't thought about that in years," he chuckled. "I think the grown-ups made the story up to keep the children in at night. There was even a curfew one winter." I asked if he was afraid of running into the Black Flash as a boy. He said no but added that he always looked over his shoulder just in case.

On Halloween night, children travel through town in search of candy. Perhaps, lurking in some alleyway or jumping from bushes, there will come a very tall, very fast, very scary black something running down dark streets.

THE GHOSTS AMONG US

Ghost hunting has attracted a large audience recently, with such shows as the Rhode Island–based *Ghost Hunters* and *Ghost Hunters International*. Cape Cod is prime ghost country, with recent episodes on the Orleans Inn and the Colonial House Inn in Yarmouth Port. Here are some ghost stories with local connections.

One ghostly tale involves Captain Roland Kelley, a sea captain who built his home on Main Street in South Dennis. The house, built in the Victorian style, holds what residents have described as a "ghostly presence." They

often hear thumps and bumps or doorknobs being rattled and even once or twice have seen the spectral outline of the man himself.

Another house, built in the late 1700s and situated on Pine Street in Dennis, was home to a spirit that could be heard by her muffled screams and rappings. Finally, the beleaguered family had the wall torn out near the fireplace where the creepy sounds were coming from. There was the curled-up skeleton of what was deemed a young woman. Once the skeleton was buried in an unmarked grave in a Dennis cemetery, the noises ceased. The family moved out shortly after, and the derelict house was eventually torn down by the town.

In Dennis Port during the 1930s, a little girl was sitting with friends in front of an old sea captain's house on Sea Street when she saw a lady in a flowing white robe. Her mother later told her she had seen the ghost of Matilda Baker. Born in 1833, Matilda died of pneumonia in 1911. Seven years after her death, Matilda's husband, a seaman, was lost at sea. Perhaps Matilda was seeking her lost love.

Residents of Sea Street in Hyannis have often encountered the "lady in blue" who carries a lamp and is usually visible walking in the direction of the sea. Many eyewitnesses believe she is from the 1800s due to the style of her long blue gown. She is only seen in the fall and winter months around dusk. The legend behind this apparition goes as follows: the husband and son of the "lady in blue" were involved in smuggling escaping slaves into Canada; they would return with illegal cargoes of rum and gold. The "lady in blue" carried her lamp down to the water's edge to wait for their return, and it is believed she is still waiting.

The islands also have their share of ghosts. At the Brotherhood Restaurant in Nantucket, visitors can take seasonal ghost tours. There has been reported an "unseen presence" that shakes furniture, rattles windows and appears in hallways. Moans and groans are heard in the stillness of night. Once a private house, dating back to 1847, the restaurant also features cold air rushing into rooms, candles blown out and even breaking glass. Perhaps with Nantucket's history as a whaling community, a loved one was lost at sea and the survivors never got over the loss. Also one of the former owners, Captain John Gardner, was once a victim of mutiny when glass was secretly mixed with his food. He was forced to live on a diet of milk and crackers after that. Perhaps he is a ghost with a predilection for shattering glass.

Ghostly happenings often involved ships at sea. In May 1893, a local schooner was found berthed at Lewis Wharf in Provincetown. Nearby was found floating a box with the name "Charles Haskell" on it. Rumor had it

that this was the same ghost ship that had a unique and tragic story of its own. Before the ship was released to sea in December 1869 from a shipyard in Cape Ann, a worker was found dead at the foot of a ladder onboard. The captain refused to take charge of the ship, saying it was now cursed. A less squeamish captain set sail for Georges Bank. During a particularly bad storm, the *Haskell* ran into the side of an unseen boat. Some of the crew members were visible before the ship sank into dark seas. The *Haskell* made it back to port, but other vessels were not so lucky. All in all, nine boats went down during that storm, and some people felt that the crew of the *Haskell* had blood on their hands.

About a week later, the *Haskell* sailed back to Georges Bank. Around midnight on the sixth night of this voyage, the men on watch saw a group of men in the bow of the ship. The spectral strangers cast splashless leads and tossed unseen fish into barrels. The ghostly sailors returned the next night to perform these same tasks again. When the figures began to leave and disappeared one by one over the rail, the last one turned and shook his head. After that, no crew would sail it. It would seem that the ghostly band had the final word.

Webster's Dictionary defines a ghost as a disembodied spirit, the soul of a dead person believed to be an inhabitant of the unseen world or to appear as the living in bodily likeness. So, when things go bump in the night, be wary of goblins, specters and, of course, ghosts.

INSPIRATIONAL LEGENDS

There have been many strong and fascinating women who inspired the hardy souls on Cape Cod and the Islands over the last three hundred years. From Lucretia Mott to Mary Oliver, intelligent women have made their mark on this wind-swept peninsula. Two of the most inspiring women to grace these shores were Katharine Lee Bates and Mercy Otis Warren.

KATHARINE LEE BATES

Katharine Lee Bates was born on August 12, 1859. Her father was a Congregational minister, and small Katharine spent her childhood in Falmouth. Shortly before she turned twelve, the Bates family moved to Wellesley Hills. Later, she entered Wellesley College. A quiet, sensitive girl, Katharine studied literature and loved the poetry of Longfellow and Whittier. She became a college professor at Wellesley. As the head of the English Department at Wellesley, she was much loved by her students. She was also instrumental in making Wellesley a center for aspiring poets.

During the summer of 1893, she wrote the first draft of "America the Beautiful" while teaching in Colorado Springs, Colorado. She was inspired by a trip to Pikes Peak. In the Library of Congress archives, she said of that trip: "One day some of the other teachers and I decided to go on a trip to

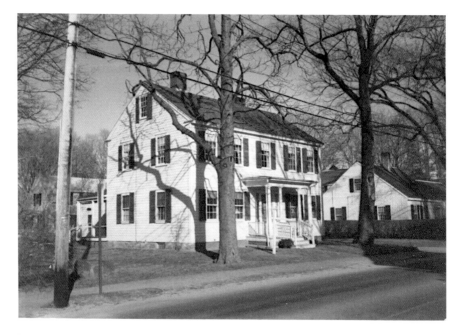

The historic home of Katherine Lee Bates off the village green in Falmouth. *Courtesy of the W.B. Nickerson Archives, Cape Cod Community College.*

14,000 foot Pikes Peak. We hired a prairie wagon. Near the top we had to leave the wagon and go the rest of the way on mules. I was very tired. But when I saw the view, I felt great joy. All the wonder of America seemed displayed there, with the sea-like expanse."

The poem was first printed in *The Congregationalist* in 1895 and later published in the *Boston Evening Transcript* in 1904 with music eventually composed for the poem by church organist Samuel A. Ward. Katharine also wrote children's stories, poetry and travel books during her life.

For twenty-five years, Katharine lived with Katherine Coman, a history and political economy teacher at Wellesley until her death in 1915. Their relationship was often termed a "Boston marriage," but it's not clear if the two were lovers. Katharine retired from Wellesley College in 1925 and died in Wellesley on March 28, 1929, at age sixty-nine. She is buried in Oak Grove Cemetery in Falmouth

Her local ties run deep with her family home on Falmouth's Main Street preserved by the Falmouth Historical Society. She also has a town road named after her. In addition, Falmouth author Leonard Miele has written a biography of her life in his book the *Voice of the Tide.*

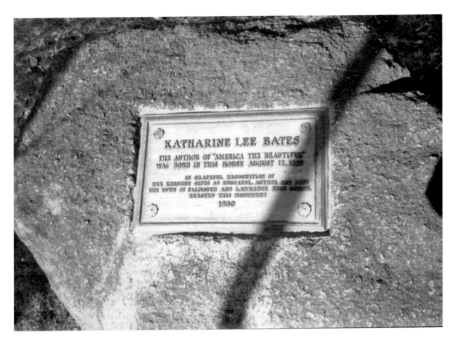

Katherine Lee Bates granite memorial plaque. *Courtesy of the W.B. Nickerson Archives, Cape Cod Community College.*

In her later years, Katharine was amazed by the success of her early poem. She wrote, "That the hymn has gained, in these twenty-odd years, such a hold as it has upon our people, is clearly due to the fact that Americans are at heart idealists, with a fundamental faith in human brotherhood."

MERCY OTIS WARREN: "MOTHER" OF THE BILL OF RIGHTS

Mercy Otis Warren was a woman ahead of her times. A West Barnstable native and the sister of Revolutionary war hero James Otis, she is recognized today for having penned a nineteen-page pamphlet that set forth the precepts that later became the Bill of Rights. Mercy wore many hats, including mother, author and supporter of civil liberties. In a 1996 *Cape Cod Times* article, a New Jersey woman, Dawn Moiras, who advocated for the creation of a statue of Mercy, stated that "without her, you wouldn't have jury trials, you wouldn't have freedom of speech, you wouldn't have a free press."

A photograph of the painting of Mercy Otis Warren by John Singleton Copley. *Courtesy of the W.B. Nickerson Archives, Cape Cod Community College.*

Local historian Marion Vuilleumier wrote that "she had to write under a pen name in the beginning because women weren't supposed to be writers." So long before George Eliot and the Bronte sisters, Mercy Otis was forced to mask her femininity in order to get her message across to a wider audience.

This extraordinary woman was born on September 14, 1728, into a family of boys. Her parents quickly recognized her potential as a scholar and allowed her to be tutored along with her brothers. She married James

Warren in 1754, and the couple settled in Plymouth. Eventually, they had five sons of their own. James encouraged Mercy's writing, calling her the "scribbler." Mercy developed a strong band of friends, including Abigail Adams and Martha Washington. She was also an advisor to many political figures, including Patrick Henry, Thomas Jefferson and George Washington. Along with her political writing, she also published plays and poems. Her most famous work may have been the 1805 *History of the Rise, Progress and Termination of the American Revolution*. In 1814, she died at the age of eighty-six in Plymouth, Massachusetts.

Now we remember her passionate words, such as "[government] is instituted for the protections, and happiness of the people not the profit, honor or private interest of any man, family or class of men," or "silence is the only medium of safety for those who have an opinion of their own that does not exactly square with the enthusiasms of the time." These are wise words for any time. There are many reminders of Mercy on Cape Cod, including her statue on the lawn of the Barnstable Superior Courthouse, created by sculptor David Lewis of Osterville. Each year, a local woman is nominated for the Mercy Otis Warren Cape Cod Woman of the Year award. This award honors an outstanding woman in the community for leadership in the arts, education or business or for her efforts "embracing the ideals of patriotism."

Because Mercy Otis Warren was willing to fight for what she believed in, her life and writings are still an inspiration for us today. For someone who lived centuries ago, her message is modern and timely.

THE AUCTIONEER
AND THE AIR CRASH

Well-known Cape auctioneer Robert C. Eldred Sr., who died in 1987, had an eventful life. Growing up on Long Island, he was childhood friends with magician and escape artist Harry Houdini. Later, he participated in the June 1944 D-day operation in Pont Neuf, France, and was wounded in battle. He moved with his wife to Cape Cod in 1947. However, he is also known for an entirely different reason. At age forty-seven, Captain Eldred was a survivor of the 1962 crash landing of an ill-fated Flying Tiger airliner in the North Atlantic in which his wife, Edna, was lost.

On September 23, 1962, Eldred and his wife boarded their plane at Maguire Air Force Base in New Jersey. As a former member of the military, he was eligible to fly with other families to Germany. He and his wife were looking forward to an antiques-buying trip abroad. Unfortunately, fate had other plans. Some 550 miles from the Irish coast, three of the four engines died, and the pilot was forced to ditch the plane into stormy seas shortly before midnight. According to testimony that Eldred later presented to the Civil Aeronautics Board, the pilot, Captain John D. Murray, gave the passengers a warning about five minutes before the plane crash-landed into the ocean. In a November 24, 1962 *Cape Cod Standard Times* article, Eldred recalled the pilot saying, "It looks like we're going to have to ditch. I will try to give you a few seconds warning before impact." He didn't remember that the pilot came on again. There were forty-eight survivors, including three of the eight-man crew, and twenty-eight people died. The four-engine plane lost one of its wings when it ditched into the sea.

A single twenty-five-man life raft was the only refuge for survivors immediately after the plane crashed. Many plane seats were torn from their mountings and flew through the nose of the plane. After impact, Eldred felt around for his wife in the pitch-black cabin, but she was gone. The plane started taking on water so he went out an open window and grabbed a floating duffle bag. He was able to swim to the raft. The survivors waited seven hours until they were picked up by a Swiss freighter, the *Celerina*. During the long wait, three of the survivors aboard the raft died: two drowned, and one woman died of terror and exposure. Eldred had bruises and burns and suffered a sprained ankle. After his ordeal, Eldred recuperated at an air force hospital in Wiltshire, England.

Captain Eldred's children, meanwhile, were at school in the United States and didn't find out about their parents' situation or about the massive rescue underway for the missing until hours after the crash. Richard, age nineteen, was a student at Middlebury College, and his sister, Karen, age seventeen, was a student at Northfield Seminary. After the terrible news that their mother was missing, the two stayed with family friends in East Dennis. A memorial service for Mrs. Edna Eldred was held on October 13, 1962, in East Dennis.

A year later, it was determined that mechanical failure plus improper action by a flight engineer disabled the engines aboard the Flying Tiger airliner. The board also found fault with crew performance and the reliability of equipment such as life rafts and jackets. After his wife's memorial service, Eldred returned to his work as an auctioneer on October 19, 1962, at the Artists and Writers for Hughes auction held at Stebbins Auditorium in Cambridge. This marked his first public auction appearance since the tragedy happened. Also, the Orleans Rotary Club voted to refurbish the watch Captain Eldred wore while he waited to be rescued that fateful September night. At this meeting, Eldred said that none of those aboard the plane expected to survive. He would live another twenty-five years and be remembered for many accomplishments, but the crash of the Flying Tiger was perhaps one of the most stirring events of his long life.

HURRICANES AND
OTHER DISASTERS

Weather on Cape Cod has always been variable and problematic. Since Cape Cod sticks out into the Atlantic Ocean, its waters are affected by the cold Canadian Labrador current from the north and the warmer waters of the Gulf Stream from the south. Temperatures are often a few degrees cooler in the summer and a few degrees warmer in the winter. Although

A postcard illustrating turbulent waves off Cape Cod. *From the postcard collection of Wendell E. Smith.*

Cape Cod weather is often more temperate than many inland locations, it has borne the brunt of many extreme weather situations. Here are a few accounts of terrible hurricanes, blizzards and one notable fire.

THE HURRICANE OF 1938

On September 21, 1938, Long Island and southern New England were struck by a powerful Category 3 storm that was responsible for massive destruction and six hundred deaths. At that time, weather forecasting was in its infancy and no one knew the storm was coming. Only one forecaster called it right—Charlie Pierce was a junior forecaster and thought the storm was on a course for the Northeast; unfortunately, the head forecaster overruled him. The conventional wisdom was that the storm would come ashore in southern Florida, but the storm picked up speed and headed northward. The impact on Cape Cod was one of devastation. Sixteen people died in the Woods Hole and Bourne areas. Damage was totaled in the millions of dollars. The storm started mid-afternoon and continued through the night, with the Bourne and Woods Hole areas most badly impacted. The Lower Cape escaped with less damage, although the winds were fierce even in this area. There was also heavy damage and one life lost on Martha's Vineyard. In the whole of New England, there were more than five hundred lives lost, and damage ran to $500 million. Over eight thousand homes were destroyed and six thousand boats damaged or wrecked. The highest wind gust of 183 miles per hour was recorded at the Blue Hill Observatory in Milton.

On the morning of the hurricane, people were only aware that a storm was brewing—"a strong gale"—but had no idea the epic proportions of the hurricane. Fire departments sent out the call for people to evacuate, but it was too late. In a *Cape Cod Standard Times* article, it was reported that "John Overy from the North Falmouth station went to Silver Beach to ask Mr. and Mrs. Andrew Jones to vacate, but they wouldn't leave their new home. Both were killed." Electricity went out, and people were left to ride out the storm in darkness. There was even looting reported in summer homes, and the National Guard was called out.

Photos from weathered news clippings from September 23, 1938, show huge downed trees, battered boats and the remains of summer homes. There's also a page taken from the *New Bedford Standard-Times*, dated October 1, 1938, and titled "Photographer Catches Storm Roaring in From Sea."

Interestingly, when it appeared that the storm was going to be intense, A.F. Packard, the young photographer sent out on this assignment, went to nearby beaches and harbors to get "surf" pictures. He took two photos: one showing the clouds forming and surf crashing at Padanaram Harbor in Dartmouth and the other a wave smashing over a wooden pier. Within minutes of these photos being taken, the hurricane hit the southeastern coast of Massachusetts at full force. Another headline read, "They didn't believe it."

The hurricane of 1938 will be remembered as the costliest and deadliest hurricane to hit the East Coast since records were first kept, but it was a Category 3 hurricane with sustained winds of 111–130 miles per hour. It's sobering to imagine a storm even stronger coming our way. Also, the area was not as developed and the population as large as we now have. An editorial from the September 21, 1998 *Cape Cod Times* edition stated that "a powerful hurricane hitting us dead-on at high tide could sweep the south side of the Cape clean, like a giant clearing off a tabletop. And there wouldn't be a thing we could do about it, except get out of harm's way."

HURRICANE CAROL

After the deadly 1938 hurricane, the next deadliest hurricane to hit our shores was Hurricane Carol on August 31, 1954. According to the National Weather Service Office, most of eastern Massachusetts had sustained winds of 80 to 100 miles per hour. The storm first made landfall on eastern Long Island and southeastern Connecticut before heading to eastern Massachusetts. On Block Island, winds gusted over 135 miles per hour (the strongest winds ever recorded there).

According to a *Cape Cod Standard Times* news article, "Winds reaching 80 miles an hour lashed at Provincetown late this morning, toppling trees, severing moorings, blowing boats ashore, knocking out windows, and scattering debris." A state of emergency was declared in Bourne, where winds of seventy-five miles per hour caused fallen trees, downed wires and power outages. Across Cape Cod, power loss was estimated at 50 percent. In Falmouth, telephone wires were down, power was out and tree limbs blown down. In Dennis Port, cottages and trailers were damaged. At the Lighthouse Inn in West Dennis, five people were marooned when water surrounded the hotel. The group was rescued by a DUKW (six-wheel-drive amphibious truck) from the Chatham Coast Guard Station.

In Chatham, winds reached eighty miles per hour, with boats lost and windows smashed at the Chatham Post Office. One casualty in Hyannis was the Melody Tent—the main tent went flying despite the efforts of fifteen people to hold it down. A tree fell down in front of the dressing rooms, where only minutes before the area had been cleared of people. Also damage to the Hyannis Yacht Club was estimated at $25,000. Many area beaches sustained damage, including beaches in Hyannis Port, Centerville, Craigville and Osterville. Crops were destroyed. Physical property sustained damage: 3,500 cars, 3,000 boats and 3,350 homes were destroyed statewide. The storm also affected rail travel. Several local fatalities were reported: Elmer Clapp, sixty-five, of Taylor's Point and two unidentified bodies found in Teaticket.

The storm also sent five people to Cape Cod Hospital with injuries. The patients ranged from a seventeen-year-old boy who suffered a broken neck from a falling tree in Marstons Mills to a seventy-year-old Osterville man who was injured when the roof blew off his beach cottage. Overall, the storm caused sixty-five deaths (fifteen of them in Massachusetts) and one thousand injuries. In fact, Carol was the first named storm to be retired. It was originally retired for ten years, reintroduced in 1965, but was later withdrawn and will never again be used for an Atlantic hurricane.

This powerful hurricane was followed ten days later by Hurricane Edna. This storm made landfall during the morning of September 11, passed over the islands and then across the eastern tip of Cape Cod. Winds were in the seventy-five- to ninety-five-miles per hour range with wind gusts of one hundred miles per hour reported in Hyannis. Twenty-one people across the region died.

Although Cape Codders have felt the brunt of several recent storms, including Irene and Sandy, the last hurricane to make landfall here was Hurricane Bob in 1991. Imagine two deadly storms arriving back-to-back. It could happen again.

HURRICANE BOB

On August 19, 1991, a feisty storm named Hurricane Bob stormed up the East Coast. When people opened their copy of the *Cape Cod Times* on that morning, they read, "Hurricane may strike area tonight/Bob takes northward track." For those who lived through this storm, the storm didn't wait until night to come ashore. The hurricane hit the Cape and Islands

around 2:00 p.m. The winds peaked at ninety miles per hour at 3:30 p.m. (wind speed and time matched in both Chatham and the Otis Air National Guard Base). Both bridges were closed at 2:00 p.m. when winds reached eighty miles per hour. One of the hardest hit areas was Taylor Point in Buzzards Bay. Property damage there was widespread, and people feared for their safety. One resident interviewed, Norberto Aflague, said, "I'm telling you, this happened so fast it was unbelievable. The water just started gushing in. The place filled up like a swimming pool." The storm also impacted tourists, and many were evacuated to ten emergency shelters around Cape Cod.

Ultimately, three deaths were attributed to the hurricane. A Bourne high school gym teacher, Rodney Valentini, was electrocuted while working with a portable generator in the basement of a restaurant flooded by the storm. A fifty-year-old Provincetown man, Arne Manos, suffered a fatal heart attack while photographing a motel roof being blown off, and a Holden man also suffered a heart attack while trying to secure his boat in Harwich Port before the storm arrived. There were also multiple reports of injuries and rescues. There was even looting reported in a vacant strip mall in downtown Hyannis during the height of the storm.

The aftermath of the storm was a story in itself. Many families and businesses were without power for days, even weeks. Trees fell on cars and houses, boats were destroyed and summer cottages floated away. People had to deal with spoiled food and lack of ice. Another widespread problem was downed power lines. Cape Cod residents were even plagued with bees angry from being displaced from their homes. The news of the hurricane competed with reports of the military coup that ousted Soviet president Mikhail Gorbachev.

The hurricane was good for a few things. Neighbors came together to help each other, and neighborhoods organized potluck suppers (a good way to use up food in a non-working freezer). Landscapers and tree experts had more work than they could handle. The effects of the storm would last for months.

One of the most moving descriptions of the hurricane was written by Douglas Horton, a Marstons Mills resident who was killed along with his wife and daughter in a 1994 head-on collision on Route 3. His sister submitted his personal essay to the *Cape Cod Times* after his death, and it was published on September 11, 1994. In this piece, Douglas writes a haunting account of his own experience of the storm. A photographer, Douglas talked about traveling around the Cape as the storm weakened and taking pictures. He wrote: "It was not until I reached the destruction at Ropes Beach (Cotuit) that I was significantly awed by the hurricane's great force. Stepping out of

the car to view some boats washed up on the shore, I noticed more on the left side of the beach, then more, and more, their white hulls tilting on the sand, crouched in places as they had landed atop one another, softly glowing in the moonlight." At the end of his essay, he finished with "And I feel sad for all those broken boats. And I feel sad for the people of the broken community of the Soviet Union. This day…will be etched in my mind forever."

THE GREAT NANTUCKET FIRE OF 1846

A massive fire devastated downtown Nantucket in 1846. The fire was fueled by whale oil, wood and high winds. It destroyed three hundred buildings (most of the island's commercial district), left one thousand people homeless and cost $800,000 in losses.

The good news was that there were no lives lost. Because Nantucket was so isolated, there was no help available. The islanders were on their own. Houses, churches and shops were left in smoking ruins.

The fire started at about 11:00 p.m. on July 13, 1846. The source of the fire appeared to be a stove pipe at W.M. Geary's Hat Shop on Main Street. After jumping to a hay loft, it spread to other buildings. The island fire companies wasted time by arguing over who should get credit for putting out the fire. Supposedly, the hostilities turned to a fistfight while the island burned down. The fire was helped by it having been a dry and windy summer. Since most of the buildings were wooden, they were quickly consumed in the flames.

Homeowners ran from one dwelling to the next in their attempts to flee the blaze. Meanwhile, firefighters blew up thirty houses in attempt to stop the fire by creating a "fire wall" of empty space. At the harbor, whale oil fueled the fire and wharves were burned down to the water. The Nantucket Atheneum Library and its legendary collection of 3,200 books (brought back by whaling men) were wiped out.

Within six weeks, islanders were rebuilding their home. The downtown now reflects the style of the mid-nineteenth century. The rural nature of the original buildings was replaced with a more urban style of architecture. Although the whaling industry was declining at this time, the community was still prosperous from its whaling heritage and was able to transform itself.

THE GREAT BLIZZARD OF 1888

On March 11, the Blizzard of 1888 struck the Northeast. It is recorded as one of the worst blizzards to ever hit this area. Interestingly, the winter of 1888 was one of the coldest on record with the so-called Children's Blizzard in January 1888. During that storm, 200 to 250 settlers, including many children, were trapped on the Great Plains of the United States when temperatures dropped quickly and howling winds and heavy snow blanketed the area. It was an uncanny precursor to the storm that followed two months later.

Before the March blizzard began, temperatures were mild and precipitation started as rain. Shortly after midnight on March 12, the storm started in earnest. The snow and wind would continue for almost two more days with people stuck in their homes. Twenty to fifty inches of snow fell in Massachusetts, as well as New Jersey, New York and Connecticut. Snowdrifts were so deep that three-story homes were swallowed in snow. This storm is sometimes called "the Great White Hurricane" because of its fierce wind and snow.

More than four hundred people died due to the extreme cold and snow; in addition, over one hundred seamen were lost with many ships wrecked during the unseasonable wicked weather. Traffic was halted for at least a week, while communication and electrical systems failed. Mark Twain, visiting in a New York City hotel and waiting for his wife, wrote, "A blizzard's the idea; pour down all the snow in stock, turn loose all the winds, bring a whole continent to a stand-still: that is Providence's idea of the correct way to trump a person's trick."

One of the consequences of this great storm was the development of the New York City subway system. With so many workers stranded by the storm, city officials deemed it wise to make plans for travel underground. The storm also saw the advent of the weather balloon as an aid to weather forecasting. However, almost one hundred years later, people still weren't prepared for another record-making storm: the Blizzard of 1978.

UFO SIGHTINGS: FACT OR FICTION

FLYING SAILS AND BLACK BLOBS

Over the years, there have been many UFO accounts across Cape Cod. Perhaps the proximity to water and flat surfaces makes this area susceptible to these eyewitness reports. In March 1964, a Wareham family (father, mother and daughter) were driving home and saw a large reddish-orange triangular-shaped object flashing above them at a height of two hundred to three hundred feet. The object, with the appearance of a sail, zig-zagged like a boat and then disappeared over Silver Lake. After reporting their sighting to Otis Air Force Base, the family could offer no explanations but were very firm on the fact that they saw a UFO.

In other early accounts of UFOS, people said in 1957 they saw "flying saucers" in South Wellfleet; in 1964, eyewitnesses declared they saw "flashing" UFOs in Hyannis; "a ball of fire" was sighted in 1953 in Barnstable; and fishermen on Truro waters sighted "a flying ball" in the same year. Another account from Chatham in 1952 described the unidentified flying object as a "black blob." In a *Cape Cod Standard Times* article, the UFO was said to be "about the size of a baseball, and the blazing tail about 100 feet long." Some scientists offered the explanation of meteor showers in the area.

Another unexplained sighting was reported in Centerville in 1950 and seen by two local residents. The object was described as traversing the heavens from the west while ascending until it could no longer be seen in

the eastern skies. The object was shaped like a rocket and made no sound. The earliest account in the archives was a sighting in Woods Hole in 1947. A couple saw a light yellow object traveling in the sky over Woods Hole. Their impression was that the thing was saucer shaped. The pair watched it for close to an hour before it disappeared.

Perhaps most unsettling was a series of articles from 1975 detailing a mysterious couple leading their band of UFO-seekers toward New England. According to a United Press International (UPI) story, "a man and a woman known as "The Two" by their followers, reportedly have promised a caravan to another world, a journey by UFO and spiritual means to another dimension." If this sounds familiar, the two people—Marshall Heiff Applewhite and Bonnie Lu Truesdale Nettles—were the leaders of the Heaven's Gate cult. In March 1997, thirty-nine members of the group committed suicide in California in order to reach what they believed was an alien space craft following the comet Hale-Bopp.

For many years, the UFO articles came every year or so. One 1964 *Cape Cod Standard Times* article reported the "latest fad…[is] night-riding little green men intent of scaring the daylight out of home-bound Cape Codders."

A UFO SIGHTING

Almost one hundred years after Scargo Tower was first built, a weird event occurred that has no explanation to this day. The story goes like this: Imagine a winter's morning with snow on the ground and thick ice on Scargo Lake in Dennis. The morning must have seemed silent and magical. Then, a mysterious object shoots across the sky and disappears behind a line of trees. This event happened on January 7, 1971, when a strange metallic object was seen by two boys on their way to school.

Although the boys saw the bright orange object independent of each other, their stories checked out. The only minor detail separating their accounts was that one boy thought he saw "a small flame at the rear of the object whereas the second boy saw only the object" (from an official National Investigations Committee on Aerial Phenomena, or NICAP, probe). One boy ran to Scargo Lake and discovered a huge hole with steam rising out of it (the hole was reported to measure twenty-five by one hundred feet). The other boy hurried on to school and told disbelieving teachers about his experience.

Over the next few days, police, newspaper reporters and the air force investigated the event. Residents also confirmed that there had been no hole in the ice the day before the glowing object was seen. According to the NICAP report, "there was no apparent way the hole could have been made literally overnight in subfreezing weather." The temperature at the time of the object's appearance was twenty-two degrees. Divers explored the area the following spring, but nothing was ever discovered.

Almost a year later, on January 2, 1972, three Hyannis boys saw glowing lights over the athletic field at the Hyannis Middle School around 6:30 p.m. In a *Cape Cod Standard Times* story, the boys described the lights as "belly-to-belly frisbees." The boys—two brothers and a friend—watched the strange lights for five to ten minutes before the blobs started moving. Finally, the lights "headed northeast, going pretty fast but keeping together. That was the last time we saw them." The boys told their skeptical mother about their experience and finally convinced her to investigate; however, nothing showed up at the Truro Air Force station, site of several big radar antennas.

BUDD HOPKINS: FATHER OF THE ALIEN-ABDUCTION MOVEMENT

One of the most prominent figures to study UFO sightings and alien abductions was Budd Hopkins, a New York artist who summered in Wellfleet. Born in West Virginia in 1931, Hopkins developed an early interest in drawing when he contracted polio at age two. He later studied at Oberlin College in Oberlin, Ohio, and after graduating with a degree in art history in 1953, he moved to New York City, where he met other abstract expressionist artists, such as Mark Rothko and Franz Kline.

He had his first UFO sighting in 1964 when he was driving to a cocktail party in Provincetown on Route 6. According to a *Cape Cod Times* article, he, along with his wife and a friend, saw a "dark, elliptical lens-shaped object hovering in the sky" over Beach Point in North Truro. They watched it for several minutes until it raced off in the late afternoon sky. This experience led him over the next fifteen years to become an amateur UFO investigator.

In 1981, he published his book *Missing Time: A Documented Study of UFO Abductions*. He began to devote as much time to his UFO investigations as he did to his art. He was in touch with people who claimed to have been

abducted by aliens. Sometimes they remembered seeing UFOs but then realizing they were "missing time." By putting these people under hypnosis, they were often able to recall frightening, disturbing encounters with aliens. An article in the *Village Voice* in 1976 made him famous. He had interviewed a New Jersey resident and recorded his findings. He speculated that aliens were not the comforting aliens of *Close Encounter* fame but were visiting earth to do scientific experiments on humans much as humans might in dissecting a frog. He also thought that there was a genetic component where aliens were impregnating women and breeding hybrid human-alien babies.

Over his lifetime, Hopkins wrote four books on the subject of alien abduction. The made-for-television movie *Intruders*, starring Richard Crenna, aired in 1992 based on his books. At the time of his death in 2011 at age eighty, he had become known as the "father of the alien abduction movement."

CAPE COD ECCENTRICS

THE GROSS SISTERS OF WELLFLEET

Nowadays, we're used to having our picture taken. It might be at a family dinner and or a vacation outing, but often a camera is a reminder to stop and pose for posterity's sake. But in 1850, having one's picture taken was a huge event. Imagine, then, when ten sisters were invited to have their picture taken in Boston. Only eleven years earlier, Louis Daguerre, a French inventor, had perfected the daguerreotype. For this undertaking, the sisters, ages fifty-six to eighty-three, had to make the trip to Boston. Although several sisters lived near Boston, the Cape sisters had to travel by special stagecoach driven by "Uncle Zeb," a popular stagecoach driver, to Yarmouth and catch the train to Boston. On their way home, they traveled by packet, those passenger-carrying ships that made trips from Cape towns to Boston and back again.

One amazing fact is that this was the first time the sisters would be together in one place. When the youngest, Maria, was born, some of her elder sisters had already married and moved away. The sisters also had four brothers and an uncle, John Young, who sailed to the Hawaiian Islands in 1789 and married the royal princess of the islands.

On the day of the photo shoot, the two youngest sisters, Maria and Deborah, balked at wearing bonnets. Maria wouldn't wear one, and Deborah compromised and let her bonnet strings hang untied. In a 1976 article in the *Cape Cod Times*, author Clarence B. Daniels wrote about the sisters: "Though their ages ranged from 56 to 83 when the daguerreotype was

taken, their gleaming dark hair and dark brows contrast with the white of their precise bonnets."

In August 1967, a reenactment of the great day 117 years earlier when the famous Gross sisters posed for their picture was staged on a float during a parade in Wellfeet. The women in this photo all wear dark gowns and white bonnets. Five are standing, with five more sitting in front. The photographer wears an artist's smock and beret and stands beside a tripod holding the early-style camera. The actresses who were on the back of the pickup truck carrying them along the streets of Wellfleet might have been uncomfortable, but they all did a good job playing their parts.

As for the real Gross sisters, they all lived long lives. Each sister married, and nine of the ten raised a family. They had a total of forty-four children between them. In Daniel's article, he writes that "at the time of her death in 1856, Lurania, the oldest, was said to have 120 living descendants." The sisters were all practicing Methodists and enjoyed hymn singing. It was also reported that sister Bethia read the Bible more than seventy times. It's reassuring to know that the Gross sisters are still remembered and honored in their native town.

A FIRE AND BRIMSTONE PREACHER

Cape Cod has always drawn a mix of religious proponents, such as the early Quakers and the more energetic "thumpers" of Eastham in the 1850s. The Puritan zeal for piety, simplicity and adherence to a strict biblical interpretation in their lives was a real force in the 1700s. When Eastham was settled by Pilgrims in 1644, the town was too poor to support its own pastor. Then, in 1672, the Reverend Samuel Treat became their first ordained minister and served the town until 1716. At the time of his coming to Eastham, the town had ninety-nine homes, two windmills, two schoolhouses and a meetinghouse.

A Harvard graduate and eldest of the twenty-one children of Connecticut governor Robert Treat, Samuel Treat was a follower of the Calvinist tradition and believed in the predestation of souls and salvation through God's grace. He was most well known for ministering to the local Indian population. He learned their language and wrote sermons for them. He also participated in their social activities and was well liked by them.

He was given an annual salary of fifty pounds by the town of Eastham, enough wood for his use and twenty acres at Fort Hill, where a house was to be built for him. Reverend Treat was a fire and brimstone preacher with a harsh, unpleasant voice. In a *Cape Cod Times* article, it was noted that a historian of the period wrote, "Modern Calvinism…is like a porcupine deprived of its quills." Treat's favorite topic to sermonize on was hell. In one sermon, Treat exhorted his listeners: "Some think sinning ends with this life, but it is a mistake…the damned increase in sin in hell." Some parishioners became ill and anxious after listening to his diatribes. It was said that his preaching was so loud it could be heard over the howling wind.

He died at the age of sixty-nine during a blizzard on March 18, 1716. The snow was so deep that it delayed his burial, so Indian friends helped to dig a trench and carried him to the ancient Cove Burying Ground. Eastham's oldest cemetery, it dates back to 1646. Treat's original headstone went missing and was replaced in the late 1800s with a marble headstone. Later, the original headstone was recovered and stored at the Snow Library but was later destroyed by fire in 1952.

AN INVENTOR'S VISION

A shoe machinery inventor, Thomas Baxendale, built a grand summer home on Amarita Island in the 1800s. Born on December 29, 1840, he grew up an orphan in Blackburn, Lancashire, England, and came to America as a child. He found a job as a shoe worker in Brockton shortly after the Civil War. Although he had little formal education, he was a gifted inventor and made his fortune after patenting the idea for a box toe for shoes, along with other patents in the design of shoe machinery and techniques.

Always an inventor and a visionary, Baxendale built a summer home for his family on Amarita Island, purchased in 1893, and situated in Cataumet, one of the villages of Bourne. The island overlooks Squeteague and Megansett Harbors. The fieldstone bridge that connects the island to the mainland was built by Manuel Brazil of Falmouth in 1895 and dedicated as a haven for cranes. Baxendale was an early conservationist and lover of animals. There are many memorials to his beloved pets on the property. In a 1927 *Boston Globe* article, his friend Dr. George Donkin said that "the horses were treated like human beings." Perhaps because Baxendale and his wife, Esther Minerva, never had children they doted on their pets.

He died at age sixty-nine on March 31, 1910. He loved the island so much that he had built a special mausoleum on the beach where he and his wife are buried. After Esther Minerva died in 1927, the estate was bequeathed to Harvard University, which in turn deeded the island to the Animal Rescue League of Boston. Until 2007, the league ran a summer camp there for inner-city children.

THE TALE OF A TORY BLACKSMITH

On June 15, 1732, the second son of David and Sarah Loring of Barnstable was born. The family eventually had two daughters and seven sons. Little Otis Loring would grow up to become the town's blacksmith and tavern keeper with the colorful nickname "Satan." He was also Barnstable's leading Tory. In a time when colonists were declaring their independence from Great Britain, being a Tory, or British sympathizer, was a dangerous occupation.

His blacksmith shop is now the site of St. Mary's Episcopal Church and the tavern across the street was located on what is now Route 6A in Barnstable. When the Revolutionary War began in 1775, a vigilante committee headed by Colonel Freeman of Sandwich went to arrest Satan and put him in jail. Fortunately, some of Loring's friends tipped him off. When the vigilantes showed up at his doorstep, he was holding out a red-hot iron that he had heated up in his forge. He made sure to only heat up the middle part so he could hold the two ends. Perhaps it was the threat of being burned or the fierce look on Satan's face, but the committee left without arresting him.

When he was visited another time by the same group, Satan hid in the back rooms of his tavern for several days. The townspeople decided to let him alone after that. Other than his politics, he was well liked in the area. In 1787, he bought a wood lot since a blacksmith needs wood to stoke his fires. Perhaps he survived the war by keeping quiet about his views so he could continue to prosper in his chosen profession.

LEGENDARY HYANNIS PORT

For many people, the name Hyannis Port has an instant allure. It is the longtime home of the Kennedys, and its history is as interesting as the place. On January 8, 1929, forty-year-old millionaire Joseph Kennedy Sr. purchased a home at 28 Marchant Avenue in Hyannis Port to support his expanding family. The two pieces of real estate on the Hyannis Port waterfront were bought from Beulah Malcomb. The new family home was intended as a summer house for Joseph's wife, Rose, daughter of a former Boston mayor, and their nine children. The youngest, Edward "Teddy" Kennedy, was only three years old.

This beautiful property originally had fifteen rooms and displayed a lawn that ran down to Nantucket Sound. The Hyannis Port home became a special place for the Kennedy family with two traditions established from the beginning. First, the family gathered every September 6 to celebrate the patriarch's birthday. Next, each Thanksgiving Day it was the custom for all the family to gather for a reunion and a traditional New England turkey dinner. Joseph Kennedy Sr. died on November 18, 1969. His last celebrated birthday on September 8 at age eighty-one had no fewer than seventeen grandchildren on hand to celebrate with him.

According to Vincent Bzdek in his book *The Kennedy Legacy*, "the cluster of clapboard houses is more an outpost than a town, a "faraway nearby" that shares the stunning geography of Cape Cod but remains isolated from it all the same…It was also a bastion of masculinity, punctuated by touch football games on the Compound's sprawling lawns, sailing

A vintage photo of John F. Kennedy Jr. sailing on the waters off his Hyannis Port home. *Courtesy of the W.B. Nickerson Archives, Cape Cod Community College.*

contests in Nantucket Sound, marathon tennis matches and open-sea swimming." In other words, it was a perfect place for the Kennedys to gather and afforded them privacy.

Hyannis Port became the site where John F. Kennedy, second son of Joseph Kennedy, set up his presidential campaign in 1960. At forty-three, John captured the Democratic nomination and would later win one of the closest elections in U.S. history. He watched the presidential election results from Hyannis Port and gave his acceptance speech at the Hyannis Armory after he won the presidency on November 8, 1960. John F. Kennedy was the youngest man ever elected president, the only Catholic and the first president born in the twentieth century.

During his presidency, Kennedy would often take the family plane, *The Caroline*, from La Guardia Airport where it had its permanent home and make the flight to Hyannis—his "summer White House." Dozens of tourists would gather at the airport in hopes of glimpsing one of the Kennedys. The president liked to slip away to Hyannis Port for rest and recreation. Known for his love of sailing, he could be seen cruising the waters of Nantucket Sound, often with his young family in tow. Sometimes he would pile the Kennedy kids and their friends onto golf carts for rides around the Compound.

John F. Kennedy Jr. driving spirited youngsters in a golf cart at the Kennedy Compound. *Courtesy of the W.B. Nickerson Archives, Cape Cod Community College.*

The months before that terrible day in November were sad ones for Kennedy with the death of his infant son Patrick. In October 1963, he took his final trip home east. He first went to Boston, where he visited Harvard Stadium to witness a game between the Harvard Crimson and the Columbia Lions. During halftime, he left and visited the grave of his newly deceased son at Holyhood Cemetery in Brookline. The next day, he traveled from Boston to Hyannis, where he said a final goodbye to his father. Five weeks later, he was assassinated in Dallas, Texas, on November 22, 1963.

During the 1960s, Hyannis Port had lighthearted moments. In August 1964, the nieces and nephews of President Kennedy had roadside stands selling JFK souvenirs and postcards. The proceeds of about $100 were to go to the John F. Kennedy Memorial Library soon to be built in Boston. The young Kennedy set often appeared in news articles with accounts of sailing contests and horseback competitions and trips to the local beaches and nearby attractions.

In more recent years, Hyannis Port was often in the news. Caroline Kennedy married Edwin Schlossburg on July 19, 1986. After their wedding at Our Lady of Victory Church in Centerville, the happy couple held their reception on the Compound lawn. Then, on July 15, 1990, Rose Kennedy celebrated her 100th birthday at the Compound (it was held in advance of

her birthday on July 22). Hyannis Port would serve as her longtime home until her death on January 22, 1995.

Recent tragic events happened here, too. On July 16, 1999, the Compound was readied for the marriage of Rory Kennedy to Mark Bailey. John F. Kennedy Jr.; his wife, Carolyn Bessette-Kennedy; and her elder sister Lauren died en route to the wedding when the small plane piloted by John Jr. crashed off the shores of Martha's Vineyard. The world waited anxiously for word of the missing plane before debris began to come ashore off the cliffs of Aquinnah. What should have been a place for celebration became a place for mourning.

In May 2008, Edward "Ted" Kennedy, John's youngest brother and a longtime U.S. senator, was diagnosed with a malignant brain tumor. The Compound had been his residence since 1984, and he often sailed aboard his ship, *The Mya*, on Nantucket Sound with his wife, Victoria Reggie Kennedy. After a valiant fight against cancer, he died in Hyannis Port on August 25, 2009.

In 2012, the main house was donated by the Kennedy family to the Edward Kennedy Institute for the U.S. Senate, which said it would host educational seminars in the house. John F. Kennedy often referred to the Compound as his true home. It was here he was most in touch with nature, with his friends and family and with his heritage.

AUTHOR'S NOTE

The *Cape Cod Times* was originally part of the *New Bedford Standard Times* and called the *Cape Cod Standard Times*. When the newspaper became its own entity in 1974, the name was changed to the *Cape Cod Times*.

BIBLIOGRAPHY

Albright, Evan J. *Cape Cod Confidential*. Harwich, MA: Mystery Lane Press, 2004.

Barbo, Theresa M. *The Cape Cod Murder of 1899*. Charleston, SC: The History Press, 2007.

Beston, Henry. *The Outermost House: A Year of Life on the Great Beach of Cape Cod*. New York: Henry Holt and Company, 2003.

Bzdek, Vincent. *The Kennedy Legacy: Jack, Bobby and Ted and a Family Dream Fulfilled*. New York: Palgrave Macmillan, 2009.

Daly, Janet M. *Images of America: Chatham*. Charleston, SC: Arcadia Publishing, 2002.

Damore, Leo. *In His Garden*. New York: Random House, 1990.

Dialect Notes: Publication of the American Dialectic Society. New Haven, CT: American Dialect Society, 1896.

Flook, Maria. *Invisible Eden: A Story of Love and Murder on Cape Cod*. New York: Broadway Books, 2004.

Friedman, Walter A. *Birth of a Salesman: The Transformation of Selling in America*. Cambridge, MA: Harvard University Press, 2005.

Gessner, David. *A Wild, Rank Place: One Year on Cape Cod*. Hanover, NH: University Press of New England, 1997.

Gordon, Dan, and Gary Joseph. *Cape Encounters: Contemporary Cape Cod Ghost Stories*. Hyannis, MA: Cockle Cove Press, 2004.

Green, Eugene, Williams Sachse and Brian McCauley. *The Names of Cape Cod: How Cape Places Got Their Names and What They Mean*. Wellesley, MA: Acadia Press, 2006.

Hayes, Helen, with Katherine Hatch. *My Life in Three Acts*. London: Peter Owen, 1991.

Jasper, Mark. *Haunted Cape Cod and the Islands*. Yarmouth Port, MA: On Cape Publications, 2002.

Keller, Helen. *The Story of My Life*. New York: The Modern Library, 2003.

Kittredge, Henry C. *Shipmasters of Cape Cod*. New York: Houghton Mifflin Co., 1935.

Lawless, Debra. *Chatham from the Second World War to the Age of Aquarius*. Charleston, SC: The History Press, 2010.

Lombardo, Daniel. *Wellfleet: A Cape Cod Village*. Charleston, SC: Arcadia Press, 2000.

Mills, Earl, Sr., and Alicja Mann. *Son of Mashpee: Reflections of Chief Flying Eagle, A Wampanoag*. North Falmouth, MA: Word Studio, 1996.

Mills, Earl, Sr., and Betty Breen. *Cape Cod Wampanoag Cookbook*. Santa Fe, NM: Clear Light Publishers, 2001.

Reid, Nancy Thatcher. *Dennis, Cape Cod, from Firstcomers to Newcomers, 1639–1993*. Dennis, MA: Dennis Historical Society, 1996.

Rosinsky, Natalie M. *The Wampanoag and Their History*. Minneapolis, MN: Compass Point Books, 2005.

Scanlon, John, ed. *Nantucket: The Last 100 Years*. Nantucket, MA: Inquirer and Mirror, 2001.

Schwarzman, Beth. *The Nature of Cape Cod*. Lebanon, NH: University Press of New England, 1977.

The Seven Villages of Barnstable. Barnstable, MA: Town of Barnstable, 1976.

Sheedy, Jack, and Jim Coogan. *Cape Cod Companion: The History and Mystery of Old Cape Cod*. East Dennis, MA: Harvest Home Books, 1999.

Simmons, William S. *The Spirit of the New England Tribes; Indian History and Folklore, 1620–1984*. Hanover, NH: University Press of New England, 1986.

Three Centuries of the Cape Cod County/Barnstable, MA, 1685 to 1985. N.p.: Barnstable County, 1985.

NEWSPAPERS AND MAGAZINES

Boston Globe
Cape Cod Standard Times
Cape Cod Times
Evening Bulletin (Providence, RI)
New Bedford Standard Times
New York Times historical archives

OTHER RESOURCES

Bowdoin College. bowdoin.edu.

Bulletin of the Massachusetts Archaeological Society.

The Colonial Williamsburg Foundation. history.org.

The Dennis Historical Society. www.dennishistoricalsociety.org.

The First Church of Sandwich. firstchurchsandwich.org.

Gatehouse Media. wickedlocal.com.

John F. Kennedy Presidential Library and Museum. jfklibrary.org.

Library of Congress online archives.

Massachusetts Historical Society. masshist.org.

New England Folklore. newenglandfolkloreblogspot.com.

Provincetown Magazine.

Public Broadcasting Service. pbs.org.

Web Exhibits, an interactive museum of science, humanities and culture. webexhibits.org.

Wellesley College. wellesley.edu.

ABOUT THE AUTHOR

Robin Smith-Johnson grew up in Orleans, Massachusetts, where she honed her love of reading and creative writing. She has degrees in English from Wheaton College in Norton, Massachusetts, and Bowling Green State University in Ohio. Currently, Robin works as the newsroom librarian at the *Cape Cod Times* and teaches in the English Department

Courtesy of the Cape Cod Times.

at Cape Cod Community College. She is the author of a book of poetry titled *Dream of the Antique Dealers Daughter* (Word Poetry, 2013). Robin lives in Mashpee, Massachusetts, with her family.